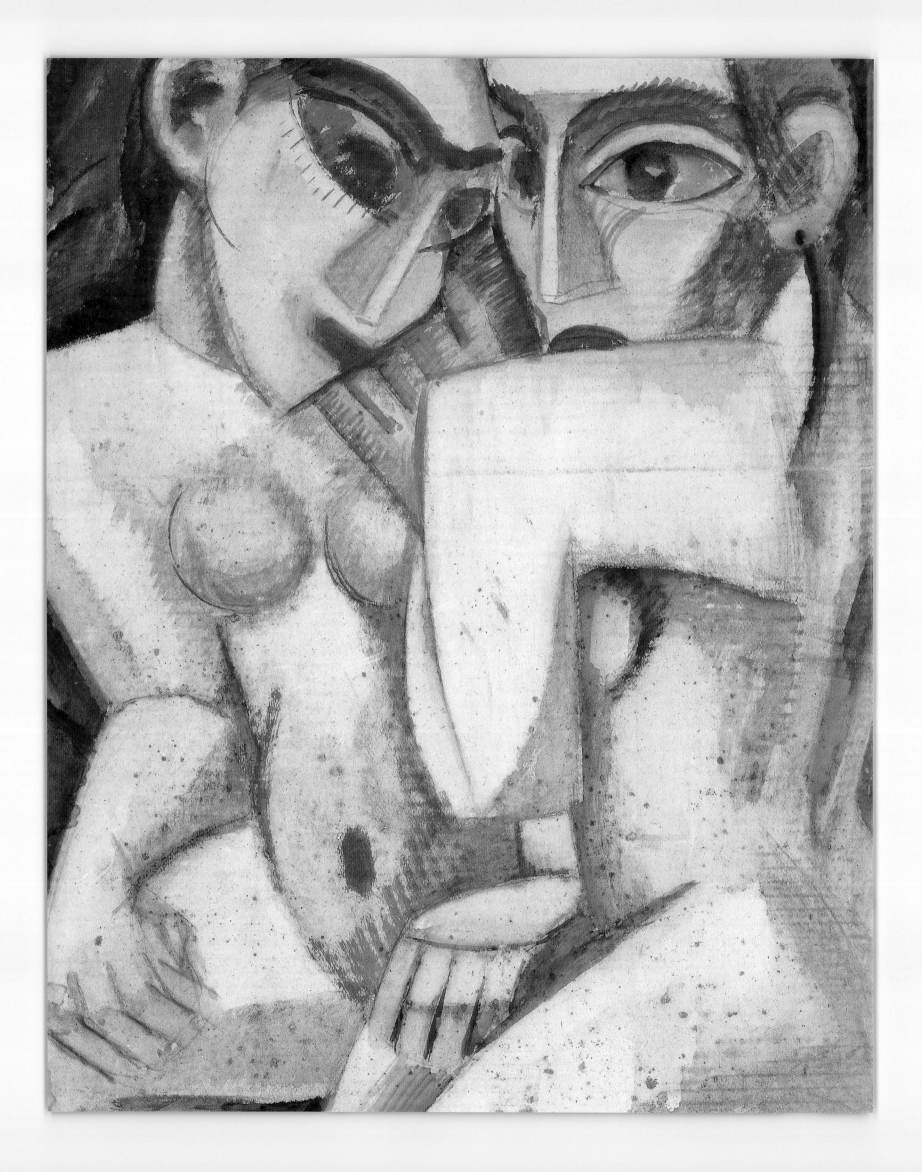

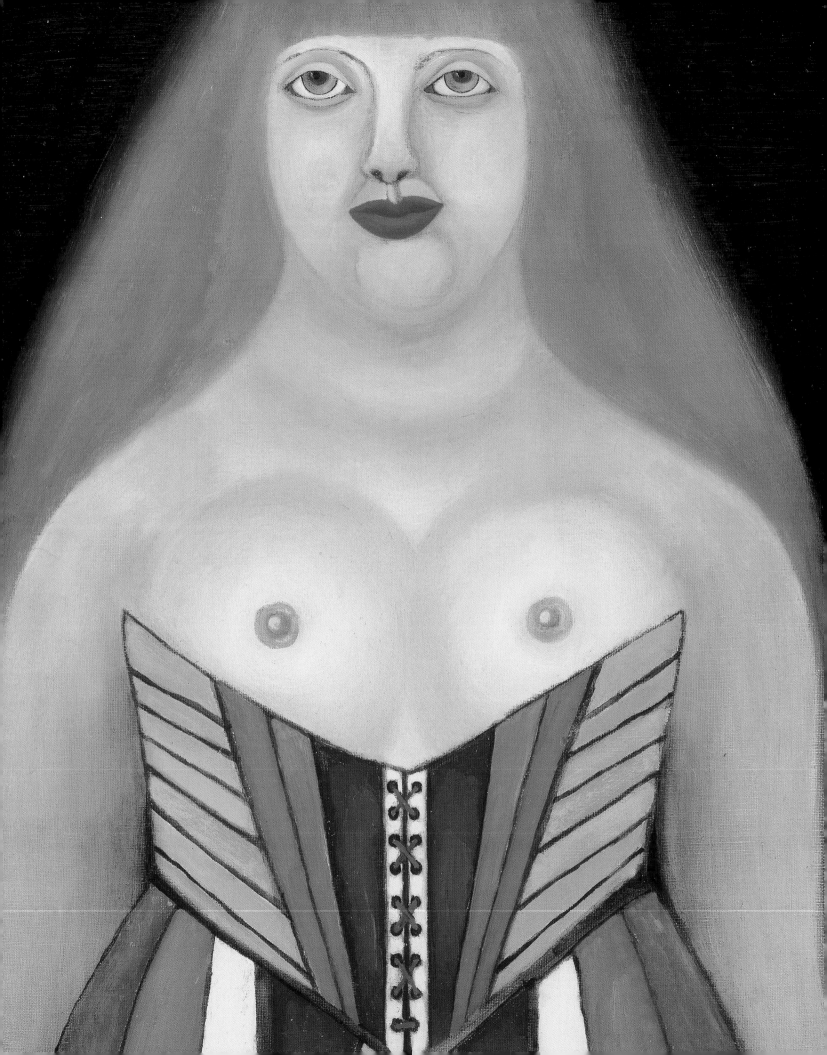

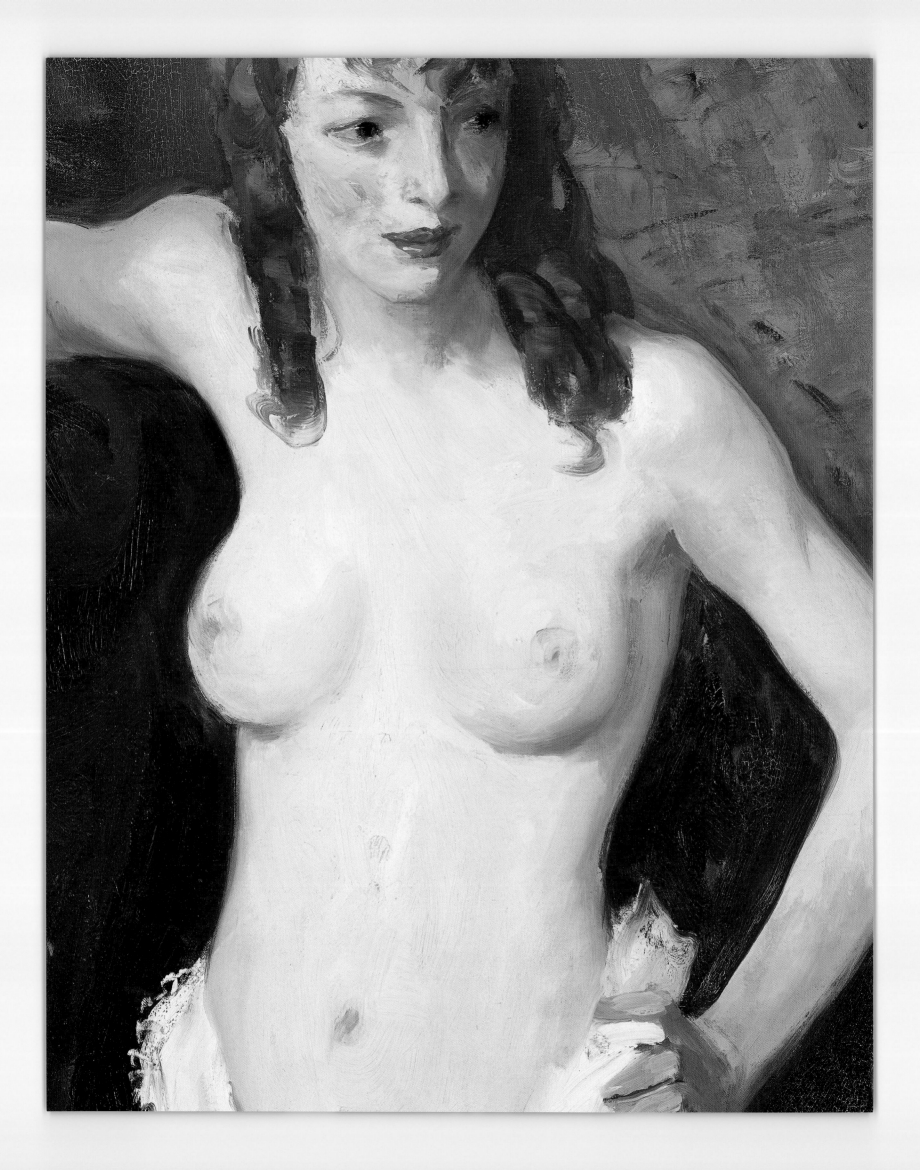

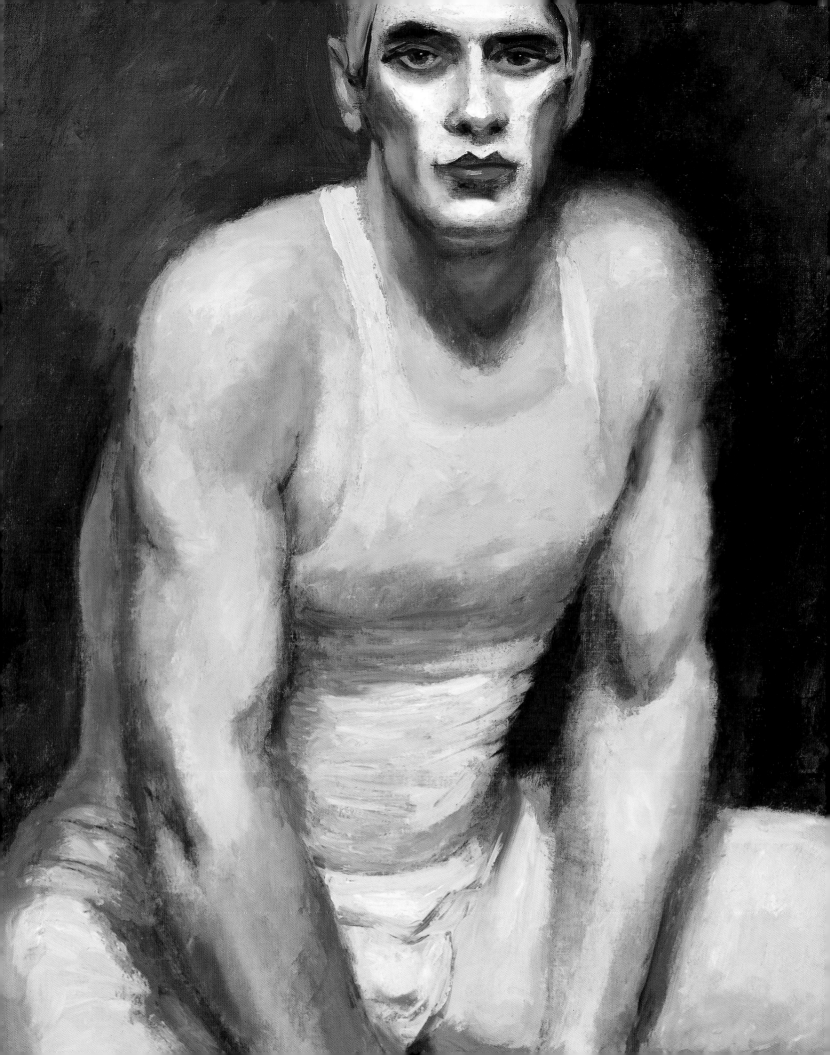

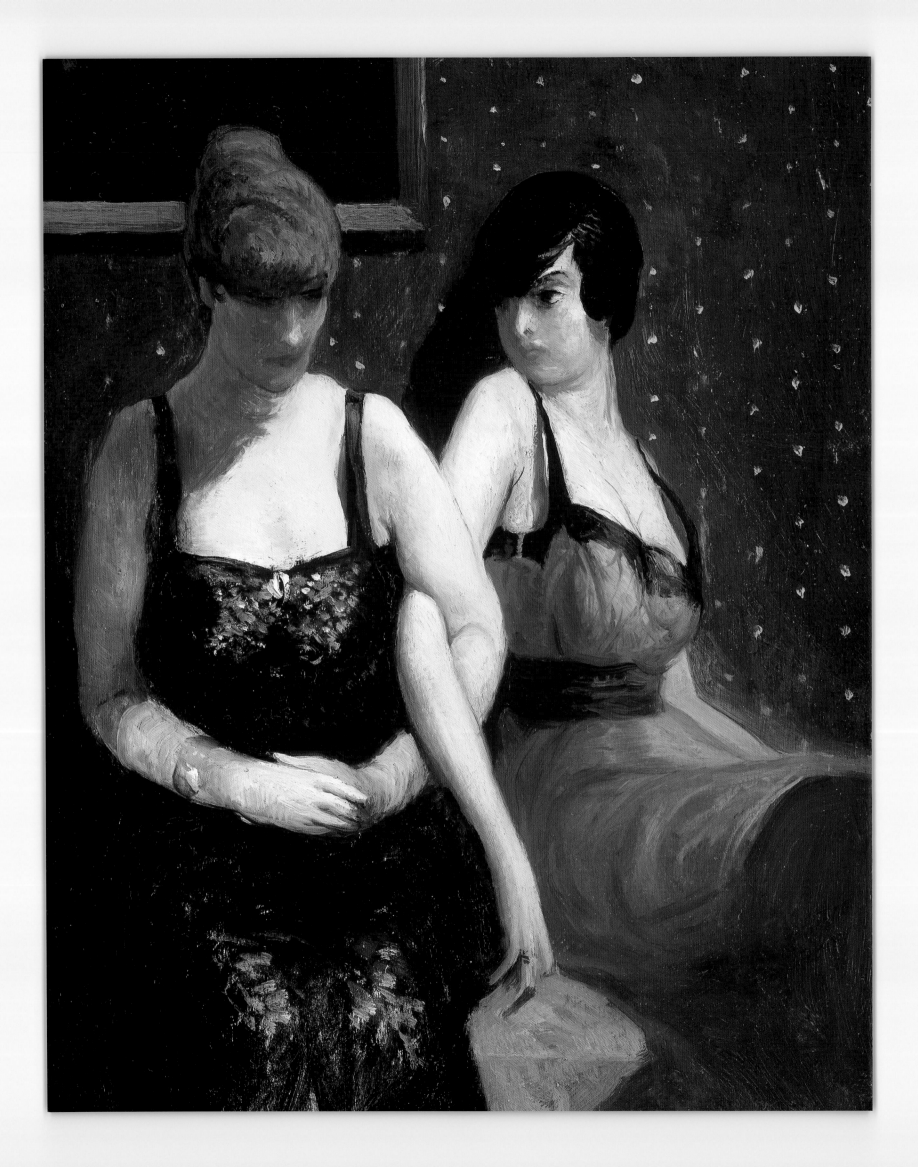

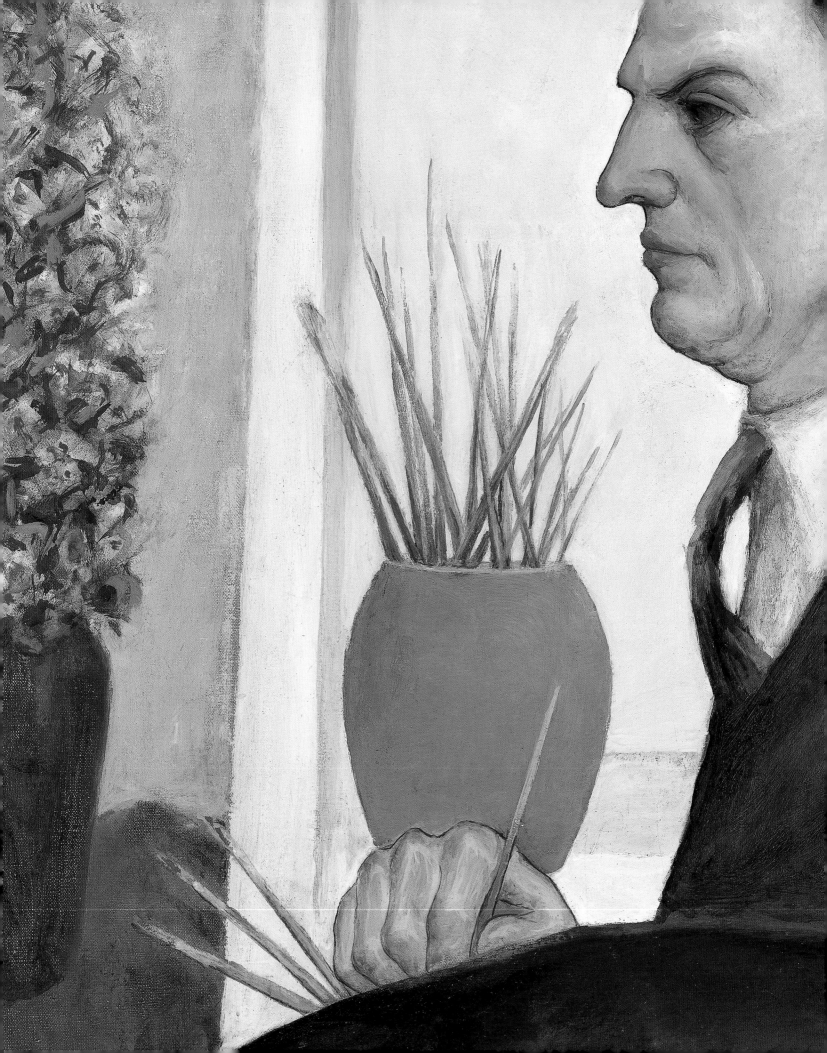

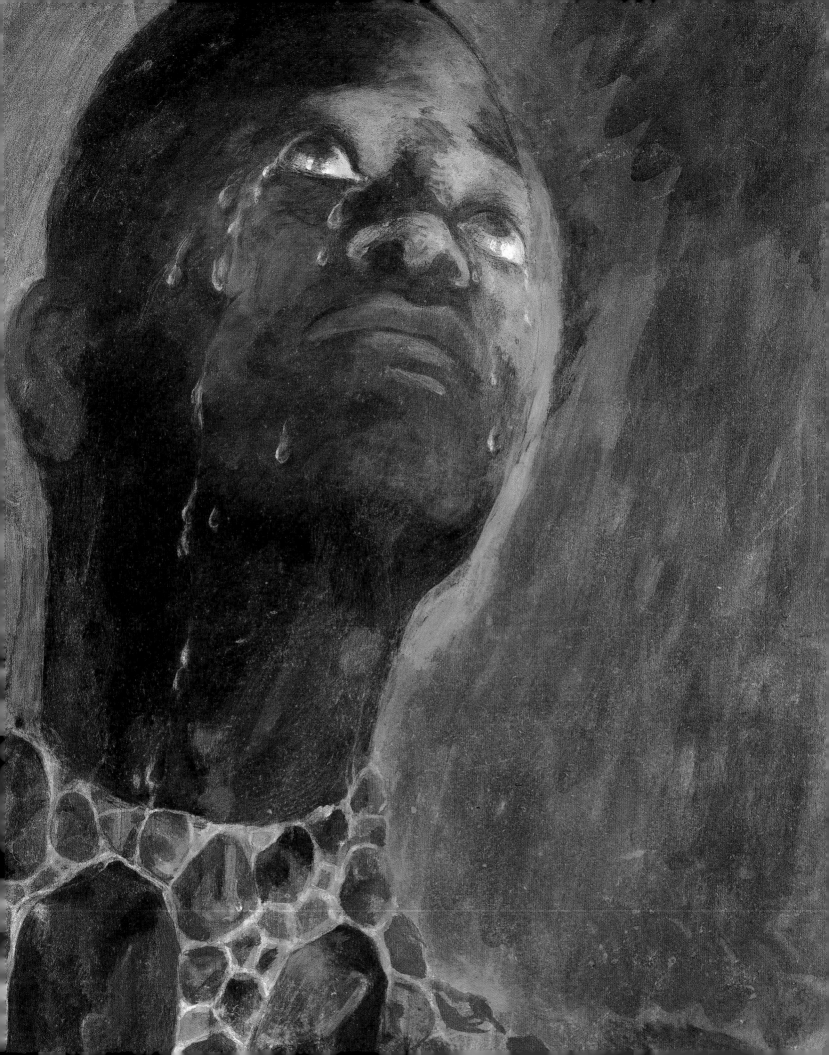

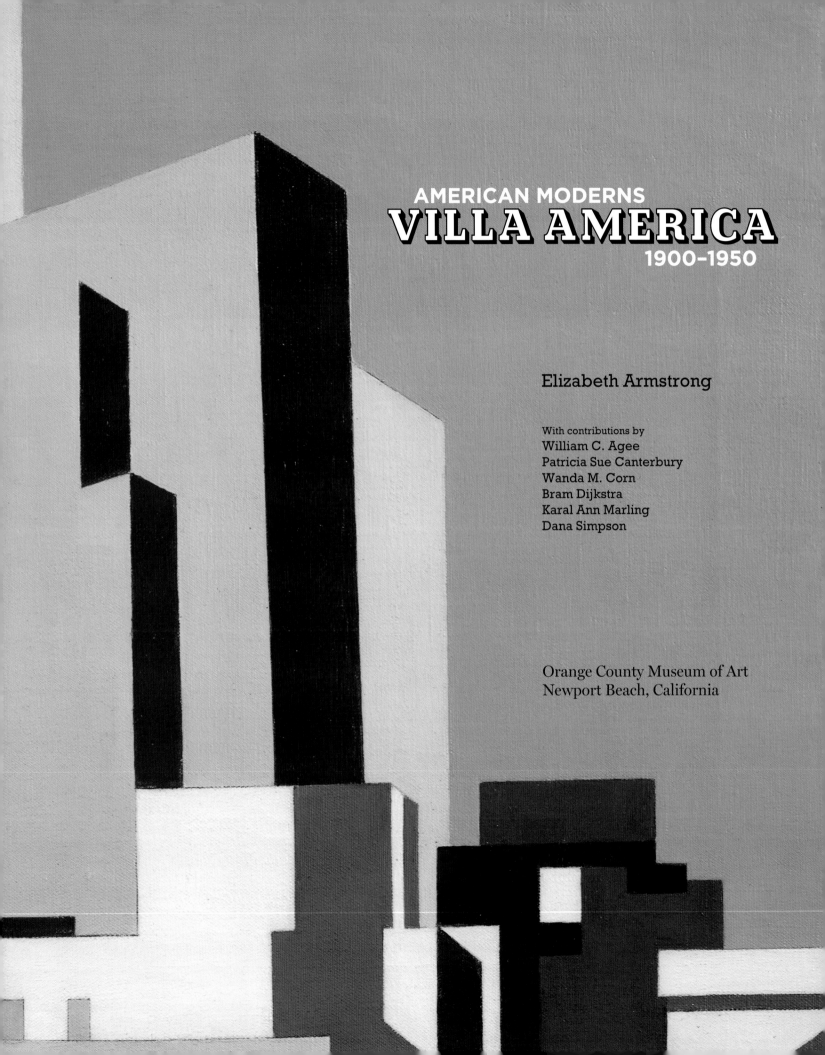

AMERICAN MODERNS
VILLA AMERICA
1900–1950

Elizabeth Armstrong

With contributions by
William C. Agee
Patricia Sue Canterbury
Wanda M. Corn
Bram Dijkstra
Karal Ann Marling
Dana Simpson

Orange County Museum of Art
Newport Beach, California

This catalogue was published on the occasion of the exhibition *Villa America: American Moderns, 1900–1950*, organized by the Orange County Museum of Art from the collection of Curtis Galleries, Inc., founder Myron Kunin.

Villa America is made possible by Victoria and Gilbert E. LeVasseur Jr., Twyla R. and Charles D. Martin, and Jean and Tim Weiss.

Major support provided by Ross and Phyllis Escalette, The Escalette Family Fund, Barbara and Victor Klein, Jim and Pam Muzzy, and Christie's.

Additional contributions provided by Bank of America, The Citigroup Private Bank, Gail and Roger Kirwan, Valaree Wahler, Wells Fargo Foundation, and Nancy and Donald Wynne.

The *Villa America* exhibition catalogue is underwritten by Curtis Galleries, Inc., founder Myron Kunin.

Media support provided by KCRW.

EXHIBITION ITINERARY

Orange County Museum of Art, Newport Beach
June 4–October 2, 2005

The Minneapolis Institute of Arts
November 13, 2005–February 26, 2006

Published by the
Orange County Museum of Art
850 San Clemente Drive
Newport Beach, California 92660
http://ocma.net

Edited by Karen Jacobson
Designed by Michael Worthington
Printed and bound by Graphicom, Italy

Villa America is a trademark of Curtis Galleries, Inc.

Library of Congress Cataloging-in-Publication Data:

Armstrong, Elizabeth, 1952–
 Villa America : American moderns, 1900–1950 / Elizabeth Armstrong ;
with contributions by William C. Agee ... [et al.].
 p. cm.
 Issued in connection with an exhibition held June 4–Oct. 2, 2005, Orange County Museum of Art, Newport Beach, Calif., and Nov. 13, 2005–Feb. 26, 2006, Minneapolis Institute of Arts.
 Includes bibliographical references.
 ISBN 0-917493-41-9
1. Modernism (Art)--United States--Exhibitions. 2. Art, American--20th century--Exhibitions. 3. Kunin, Myron--Art collections--Exhibitions. 4. Art--Private collections--United States--Exhibitions.
I. Agee, William C. II. Orange County Museum of Art (Calif.) III. Minneapolis Institute of Arts. IV. Title.
 N6512.5.M63A76 2005
 709'.73'07479496--dc22
 2005017849

FRONT AND BACK COVERS:
Gerald Murphy, *Villa America*, c. 1924 (cat. no. 45)

PAGES 1–13:
Theodore Roszak, Man at Machine, 1937 (detail, cat. no. 56); Max Weber, *Two Seated Figures*, 1910 (detail, cat. no. 74); Richard Lindner, *Woman in a Corset*, 1951 (detail, cat. no. 41); Robert Henri, *Edna Smith (The Sunday Shawl)*, 1915 (detail, cat. no. 36); Walt Kuhn, *Roberto*, 1946 (detail, cat. no. 39); Guy Pène du Bois, *The Sisters*, 1919 (detail, cat. no. 51); Arnold Friedman, *Self-Portrait in Profile*, 1936–38 (detail, cat. no. 29); George Tooker, *The Supermarket*, 1973 (detail, cat. no. 73); Pavel Tchelitchew, *Weeping Negro*, 1934 (cat. no. 70, detail); Bernard Perlin, *Autumn Leaves*, 1947 (detail, cat. no. 54); Raphael Soyer, *Flower Vendor*, 1935 (detail, cat. no. 67); Grant Wood, *Return from Bohemia*, 1935 (detail, cat. no. 75); Andrew Wyeth, *The Huntress*, 1978 (detail, cat. no. 77)

PAGES 14–15:
Charles Sheeler, *New York No. 1*, 1950 (cat. no. 65)

PAGES 112–13:
Arthur Dove, *Dancing Tree*, 1930 (detail, cat. no. 24)

PAGES 114–15:
Alexander Brook, *Peggy Bacon on Sofa*, 1922 (detail, cat. no. 7)

CONTENTS

Foreword 18

The "Picture-Looker" 21
Elizabeth Armstrong

Foreword

Villa America: American Moderns, 1900–1950 presents for the first time one of the most celebrated private collections of American art from the first half of the twentieth century. Over the past thirty years, Myron Kunin has assembled more than six hundred works, including many of the finest paintings by virtually every significant artist of the era. Yet some of the most exciting revelations here reflect Kunin's interest in less recognized but highly illuminating works by well-known figures, such as wonderful early landscapes and portraits by Stuart Davis, as well as his attraction to complex self-portraits and his affinity for intimate, often unnerving nudes. Kunin's maverick sensibility melds with a devotion to great painting and offers a highly personal entry into the American century.

It is with tremendous gratitude that we thank Myron Kunin and his wife, Anita, for allowing us to work with this distinguished collection, for their generous financial support of this beautiful catalogue, and for their willingness to share these exceptional paintings and sculptures with visitors to our museum. The collection is under the aegis of Curtis Galleries, Inc., of which Myron Kunin is the founder and president. Jenny Sponberg, registrar, Curtis Galleries, Inc., provided invaluable assistance with the myriad details of organizing the exhibition and catalogue. Following its premiere at the Orange County Museum of Art, *Villa America* will travel to the Minneapolis Institute of Arts, and I thank Robert D. Jacobson, the institute's acting associate director of collections and exhibitions, for his enthusiasm and support of the project.

Just as *Villa America* represents the unique vision of an astute collector, it is also stamped with the unmistakable style and intelligence of Elizabeth Armstrong, deputy director for

programs and chief curator, perhaps the only person on the planet Myron would entrust with this endeavor. Liz's twenty-year association with the Kunins (stretching back to her graduate thesis on Paul Cadmus), her inspired concept for the exhibition, and her passion for this period of American art were all essential to convincing an often reluctant and extremely humble Myron Kunin to let us make the show. Special thanks to Irene Hofmann, curator of contemporary art, for her assistance in overseeing the production of the exhibition catalogue; to Karen Moss, curator of collections and director of education and public programs, for creating the first iPod audio tour at an American museum and for developing an outstanding range of lectures, film series, and concerts based on *Villa America*; to Janet Lomax, curatorial associate, for her considerable talents, including expert project coordination and the ability to keep everyone on track; to Dana Simpson, curatorial research associate, for providing invaluable background material about the art on view; and to Brian Boyer, exhibitions and facilities manager, and Tom Callas, registrar, for their always superb work.

Once again, Gilbert and Victoria LeVasseur Jr., Charles and Twyla Martin, and Tim and Jean Weiss have come together to support a major project at the museum. *Villa America* marks a new level of curatorial achievement for the museum, and these three exceptional couples have always encouraged us to reach higher and are among the first to step forward when we've hit the mark.

The same may be said about Jim and Pam Muzzy, Victor and Barbara Klein, and Ross and Phyllis Escallette, who consistently and graciously help us in so many ways. Ross Escallette accompanied Liz and me on an early visit to the collection at the Regis Corporation's Minneapolis

headquarters, and his initial support of the project was a great boost. Christie's, Citibank, and Wells Fargo have provided key corporate support for *Villa America*, and I would especially like to thank Andrea Fiuczynski, Allison Whiting, and Eric Widing of Christie's; Douglas Gourley and Jennifer Van Bergh of Citibank; and Jack Toan and Cynthia Tusan of Wells Fargo for their involvement in the project. Essential funding has also come from Gail and Roger Kirwan, Valaree Wahler, and Nancy and Donald Wynne.

We are greatly appreciative of the writers who joined us in this publication: William C. Agee, Patricia Sue Canterbury, Wanda M. Corn, Bram Dijkstra, Karal Ann Marling, and Dana Simpson. Their cumulative intelligence, knowledge, and wit deepen and expand upon the experience of the artworks on view, while their individual voices parallel the distinct identities of the artists about whom they have written. We are very grateful to Karen Jacobson, our editor, whose attention to their rich texts was appreciated by all of our authors. Infusing this publication with his customary energy and vision, Michael Worthington has created a fresh design that perfectly complements the independent sensibility of the collection.

The generosity of the Kunins and of the donors who provided funding for *Villa America*, combined with the energy and talent of all those who participated in the organization of the exhibition and catalogue, have made it possible for us to share this extraordinary private collection with the public, and we are deeply grateful for this opportunity.

Dennis Szakacs
DIRECTOR
ORANGE COUNTY MUSEUM OF ART

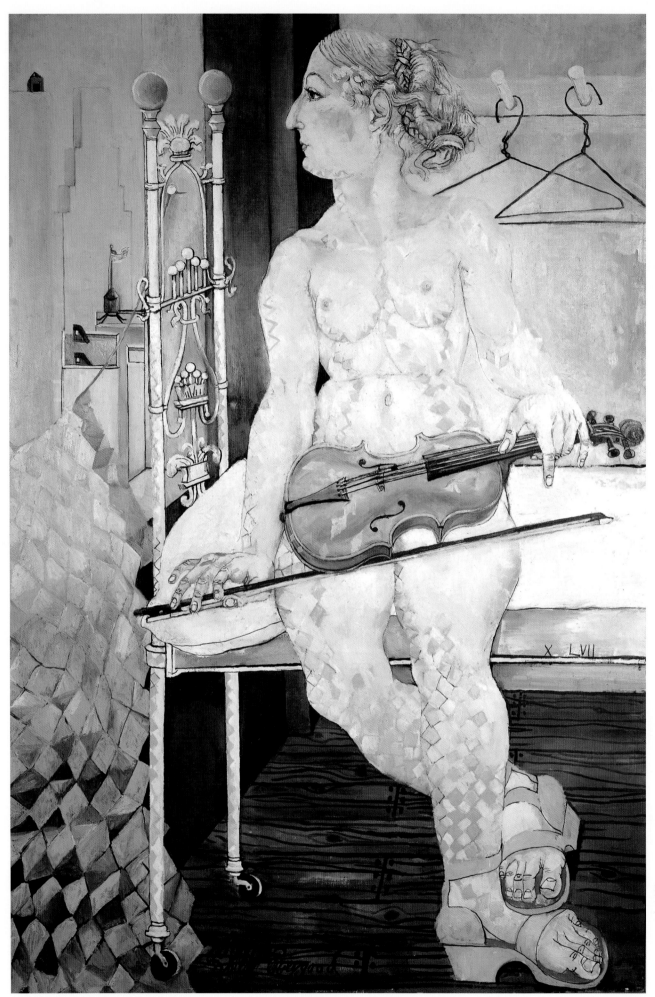

Fig. 1
Philip Evergood
Nude with Violin, 1957
Cat. no. 26

The "Picture-Looker"
Elizabeth Armstrong

In the late 1970s people knowledgeable about American art began hearing about a collector in Minneapolis who was quietly assembling an extraordinary body of work by American modernists. From its earliest acquisitions, one of the most striking aspects of this collection was its originality.

Unconcerned about whether an artwork fell within the mainstream of accepted currents in art history, the collector was looking for certain qualities over pedigrees, responding to the art and not the label. He was acquiring major works by little-known modernists such as Morton Schamberg and Arnold Friedman, searching out illuminating works by out-of-vogue realist painters such as Jared French and Philip Evergood, and finding atypical pieces by such celebrated masters as Marsden Hartley and Arthur Dove. When the opportunity arose, he hopped on a plane to Washington, D.C., to look at one of the few remaining works still in private hands by the expatriate American painter Gerald Murphy, *Doves* (1925; fig. 33), which was hanging in the home of the artist's daughter.

This independent-minded collector with the unpredictable bent and great eye is a low-profile businessman named Myron Kunin, former chairman of the Regis Corporation in Minnesota. As a young man, Kunin took over his family's business, and although he was clearly highly successful, expanding it into a much larger enterprise, he found that running a business did not fully engage his interest. With characteristic candor, he recently told an interviewer: "This wasn't a business I wanted to be in, partly because it was my father's business." The ancillary benefit to Kunin, when he started collecting, was that the growing company's ever-expanding offices offered copious wall space. The challenge of filling those walls provided an impetus for Kunin to keep collecting, and that

became his primary interest: "It became a whole way of life for me that was fascinating, and I still love it. It's more important to me than business." In fact, by the late 1970s the business had become routine for Kunin, and he spent more and more time learning about various art movements and became increasingly absorbed in building a collection. But this is not to suggest that he got his education primarily by poring over art history books. As Kunin explains, "I'm not a good reader. I'm a good picture-looker."[1]

The complex, eclectic, and unique collection that Kunin has formed over the past thirty years is ample evidence that he has developed an extraordinary eye for pictures. His embrace of consistently high-quality works by well-known and unknown artists alike has resulted in a collection that covers a wide swath of aesthetic styles and movements and expands upon traditional notions of American art. *Villa America: American Moderns, 1900–1950* presents more than seventy-five works from this dynamic collection, which have been selected to convey a sense of its diversity and its independent spirit. Each of these works is reproduced in this catalogue in an illustrated checklist organized alphabetically by artist. The book also examines a selection of these works in depth, with newly commissioned texts accompanied by full-page reproductions. Organized in chronological order, these entries allow the reader to follow the nonlinear evolution of American art during the first half of the twentieth century in a somewhat linear fashion.

Notes
1. Suzanne Muchnic, "A Rare Look at Beauty's Spoils,"
 Los Angeles Times, June 5, 2005, Calendar sec.

Fig. 2
Charles Sheeler
Abstraction, Tree Form, 1914
Cat. no. 62

Fig. 3
Charles Sheeler
*Conversation—Sky and
Earth,* 1940
Cat. no. 63

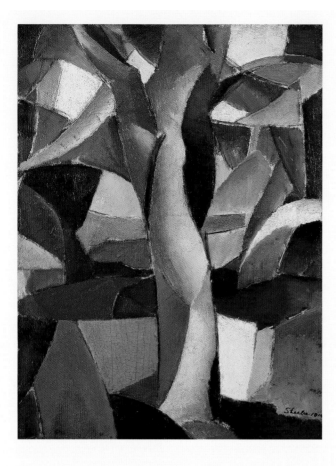

American art and artists, which was especially vibrant during the first two decades of the century, is central to the story of modern American art. Many American artists received their first exposure to European modernism at the Armory Show in 1913—for example, in his entry on Stuart Davis in this volume, William C. Agee notes the "immediate impact" the exhibition had on the artist's work—and this inspired some of them to travel to Europe. During these years, artists such as Davis, Charles Demuth, Arthur Dove, Marsden Hartley, Georgia O'Keeffe, Morgan Russell, Morton Schamberg, and Charles Sheeler experimented with new ideas and forms to transform traditional subject matter into avant-garde statements of personal expression, in the process reshaping American art.

The works by these key American modernists are one of the collection's great strengths. Not content to focus the collection narrowly, Kunin has acquired the work of these artists in depth, tracking the transformation of their art over the course of their careers. The collection includes an early canvas by Sheeler, one of the most experimental of the Americans working in the early twentieth century. In a work such as *Abstraction, Tree Form* (1914; fig. 2), Sheeler pushed representational form to the edge of abstraction. Notable examples of this artist's later embrace of an almost photographic realism, such as *Conversation— Sky and Earth* (1940; fig. 3), are also found in this collection. Hartley is another artist whose early innovations placed him at the center of modernist art. In his later years, he developed a unique style of figuration, drawn as much from traditions of American primitive and folk art as from European modernism. The collection features the fullest range of this American visionary's remarkable output, from his dynamic abstractions of the 1910s, such as *A Nice Time* (1915; cat. no. 32), to his heroic midcentury portrayals of the country's downtrodden, such as *Prayer on Park Avenue* (1942; fig. 53).

The exhibition takes its title from the name of a work in the exhibition, Gerald Murphy's *Villa America* (c. 1924; fig. 32). This small painting in tempera and gold leaf was created as a signboard for the home on the French Riviera owned by the artist, which served as a gathering place for American and European modernists through the 1920s. In the same way that Villa America was energized by an intoxicating mix of artists, writers, and other cultural movers and shakers who came together there—including Pablo Picasso, Fernand Léger, Man Ray, Jean Cocteau, F. Scott and Zelda Fitzgerald, Ernest Hemingway, Dorothy Parker, and Cole Porter—this art collection is animated by the rich diversity of artists and works sharing space, from the bicontinental pioneers of early American modernism to the antibohemian and defiantly realist midcentury painters.

In his friendships and his lifestyle, Murphy comfortably merged aspects of European sophistication with his family's own distinctly American background. This was also reflected in his work. As John Dos Passos wrote, "Gerald's painting when it was shown in Paris was the epitome of the transatlantic chic."[2] Indeed, the interchange between European and

2. John Dos Passos, in Wanda M. Corn, *The Great American Thing: Modern Art and National Identity, 1915–1935* (Berkeley, Los Angeles, and London: University of California Press, 1999), 99.

By the early 1930s the parties at Villa America had come to an end, and the Murphy family locked up their beloved villa in southern France and returned to America. The somber mood that accompanied them back to the States—the fallout of various family problems—was mirrored at home by the stock market crash and the onset of the Depression. While a number of American modernists, such as O'Keeffe and Dove, continued to explore formal innovations in their work, the extended period of artistic experimentation and cosmopolitanism epitomized by Murphy and his "lost generation" contemporaries had largely come to an end. It was replaced by a more realistic mode of art making with themes reflecting regional values and a new sense of social responsibility.

One of the many paintings in this collection that capture the sobering change of mood in American art during this period is Grant Wood's *Return from Bohemia* (1935; fig. 46). Wood had visited Paris off and on in the 1920s, but he ultimately rejected the bohemian lifestyle that he had adopted while abroad. By the late 1920s he had decided to become a regionalist painter of the Midwest and went on to make some of the most famous paintings of the century. An icon of twentieth-century

Fig. 4
Paul Cadmus
*Aspects of Suburban Life:
Main Street,* 1937
Cat. no. 10

American art, his *American Gothic* (1930) was inspired by
both regional traditions and northern Renaissance painting.
Featuring a dour farmer, with pitchfork in hand, and his spin-
ster daughter, this work takes the country's new sobriety to an
extreme. Yet, as art historian Karal Ann Marling suggests in
her entry on Wood for this book, lurking beneath this Amer-
ican master's seemingly reverential paintings of the heartland
is a sense of ambiguity and critique. *Return from Bohemia* can
be seen as a glorification of the moral virtues of rural America,
but it might just as easily be read as a comment upon the
provinciality of midwestern culture.

Another American original represented in the collection, the
painter Paul Cadmus was anything but subtle when it came to
depicting American life. He too spent a brief sojourn in Europe,
where he lived and worked with his friend Jared French from
1931 to 1933; upon his return to the United States he turned
his attention to painting the "American scene." Eschewing
the political utopianism of the Depression years, however,
Cadmus's paintings are unique in their satirical portrayal of
the class and racial conflicts of American society—an approach
rarely seen in the art of this period. His painting *Aspects of
Suburban Life: Main Street* (1937; fig. 4) was designed as a

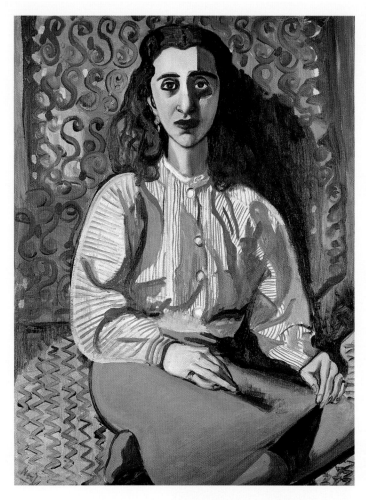

Fig. 5
Alice Neel
Young Woman, 1946
Cat. no. 47

made in the early 1930s illustrating the trial of Nicola Sacco and Bartolomeo Vanzetti, the Italian-born anarchists whose conviction and execution on charges of robbery and murder were attributed to political motives, to later works such as *Death of a Miner* (1949; cat. no. 61)—were politicized in a way rarely seen in European art of the period. Born in Lithuania, Shahn identified with recent immigrants and others marginalized by mainstream American culture. His *Self-Portrait among Churchgoers* (1939; fig. 49) conveys an outsider's point of view, in this case of a certain sort of religious sanctimony. Shahn painted himself standing off to the side of the image, dressed in flashy street clothes that contrast with the dress black of the good parishioners. Seemingly oblivious to their approach, the artist is surreptitiously photographing them using a right-angle viewfinder that allowed him to face away from his subjects while photographing them. The church's signboard announces a sermon on the theme of "irreligion in art."

The critical and nonconformist attitude of artists such as Shahn and Cadmus is telling in regard to Kunin's holdings. It suggests an affinity not only for the outsider and the iconoclast but also for the artist on a personal quest. The collector's passionate embrace of an eclectic range of artists and styles has been cultivated on highly individual terms, at the core of which is an attraction to confrontation. Kunin has often said that he likes an artwork that "gives you eye service," and the collection's portraits and figural paintings are particularly strong in this respect.

Although there was a general decline in support for figurative art in the United States after midcentury, this collection reflects its great flowering during the first half of the century. In Alexander Brook's strikingly frontal 1929 portrait of the New York painter Raphael Soyer, for example, the subject seems about to step out of the painting (fig. 6).[3] Another artist

mural for the post office in Port Washington, New York. It had been commissioned by the Treasury Relief Art Project, a New Deal program that supported artists during the Depression. In her entry on this painting, Marling comments, "The Great Depression did not call for leering loafers, tennis players, and wild disorder—at least not in government-sponsored murals." The salaciousness of Cadmus's subjects—incongruously rendered in a style inspired by Italian Renaissance painting—did not sit well with the civic leaders of suburban Port Washington, and the painting was shipped back to the artist shortly after it was received.

From 1935 to 1938 the young painter Ben Shahn traveled through Depression-era America as a staff photographer for the Farm Security Administration (FSA). He was employed by this government program to document the lives of Americans during this difficult period. Already impassioned by political and social struggles within American society, Shahn witnessed firsthand the intense poverty and dislocation of Americans throughout the country. His Social Realist paintings of the next two decades—from his series of paintings

3. In fact, art dealer Larry Salander of Salander-
O'Reilly Galleries recalls that, during the opening
at which Myron Kunin first saw this painting,
Raphael Soyer himself walked into the gallery,
wearing a similar overcoat (Larry Salander, interview by the author, May 12, 2005).

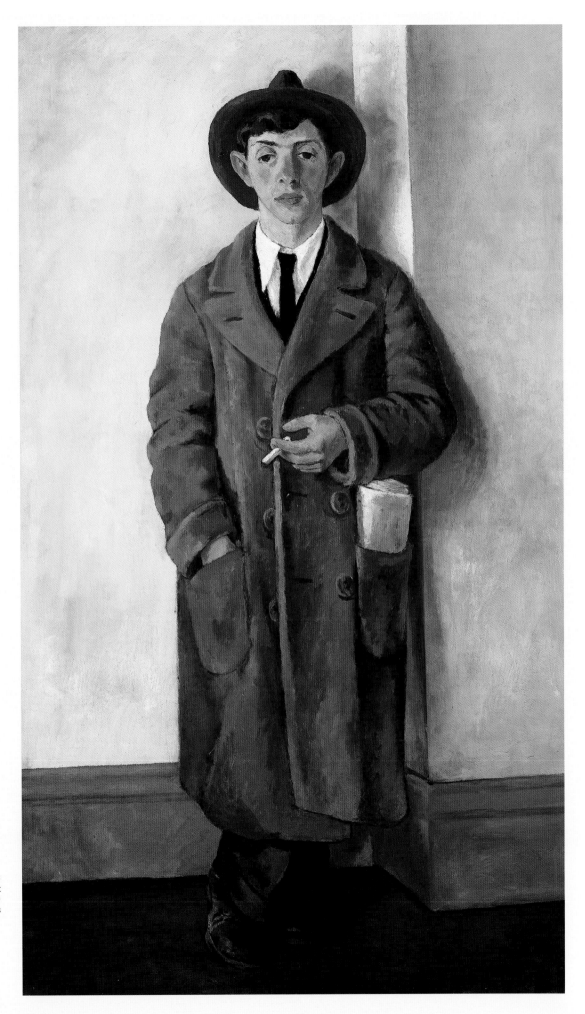

Fig. 6
Alexander Brook
Portrait of Raphael Soyer, 1929
Cat. no. 8

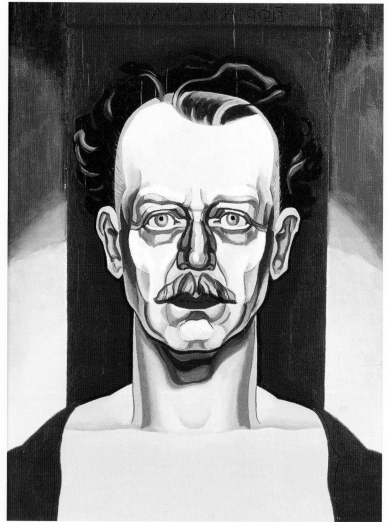

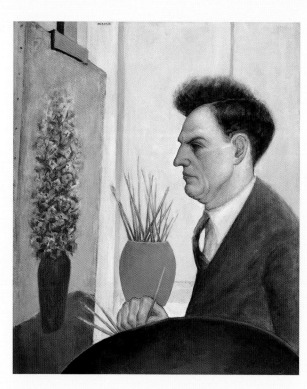

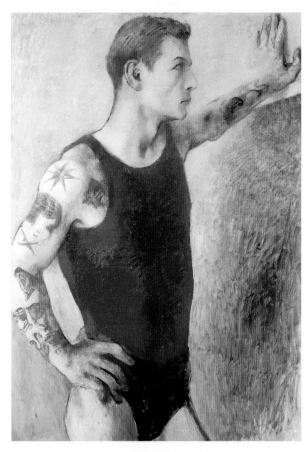

Fig. 11
Pavel Tchelitchew
Acrobat in Red Vest, c. 1930
Oil on board
41 1/2 x 29 3/4 in. (105.4 x 75.6 cm)
Collection of Curtis Galleries, Inc.,
founder Myron Kunin

in the collection who made portraiture her primary focus, Alice Neel often depicted working-class women in images that have been described as confrontational and unflinchingly honest (fig. 5). Bringing her own experience and knowledge to bear on these poignant images, she made portraits that reveal the physical toll taken on those in the lower echelons of society. Although Neel was professionally trained, her preoccupation with the figure marginalized her among her contemporaries, and she remained an outsider to the art world until discovered by the feminist movement in the 1970s.

The collection includes a remarkable number of self-portraits—by artists such as Paul Cadmus, Stuart Davis, Philip Evergood, Arnold Friedman, Joseph Stella, and George Tooker—and they are among its most personal and intimate images. Notable for their psychological intensity and depth, these images offer unique insights into the personalities and practices of the artists. Cadmus, for instance, seductively draws the viewer into his narcissistic self-portrait with unabashed virtuosity (fig. 7), while Friedman, a very talented but little-known artist, seems utterly nonplussed by the painting he has made of himself (fig. 8). The collection also includes a formidably expressionistic self-portrait by the modernist landscape painter Oscar Bluemner—the only known painting he made of himself (fig. 10).

The collection's riveting and often erotic paintings of the figure do not reflect the traditional biases of collecting. Not only are there a number of highly sensual female nudes, but vigorous male bodies are also on display. Robert Henri's *Edna Smith (The Sunday Shawl)* (1915; fig. 25), a portrait of a striking redhead, captures his young sitter's sensuality with directness and erotic spontaneity. Marsden Hartley, in contrast, conveyed a raw and forceful masculinity in works such as *Madawaska—Acadian Light-Heavy* (1940; fig. 13). The deep, almost blood red of the painting's background accentuates the young man's muscular strength and robust sexuality.

Hartley is one of a number of gay artists represented in the collection who made paintings of the male figure that would be considered homoerotic by today's standards. At the time, however, their homoerotic content was often coded for insiders and not written about by the popular press. On close inspection, for instance, the gaze of the muscular blond street tough in Cadmus's *Aspects of Suburban Life*, who is sitting on a very phallic fire hydrant, appears to be focused not on either of the leggy females walking down Main Street but, rather, on their preppy-looking male companion. Pavel Tchelitchew, the Russian-born painter and set designer who worked in Europe during the 1920s and early 1930s before settling in New York, made numerous images of male circus and stage performers of a more openly carnal character (fig. 11). Other works in the collection can be interpreted as alluding to the anxiety associated with being gay in midcentury America. A curious painting titled *Evasion* (1947; fig. 12), made by the bisexual artist Jared French, portrays several naked men, one covering his genitals, suggesting the shame and repression associated with homosexuality during this period.

Fig. 12
Jared French
Evasion, 1947
Cat. no. 28

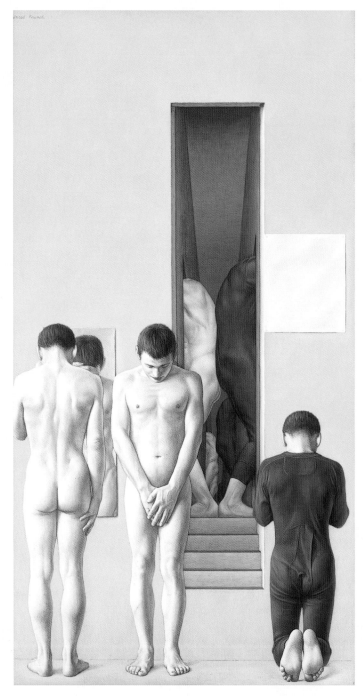

And yet, on balance, the gendered bodies found in these passionate paintings are ultimately—to quote Bram Dijkstra, writing in this volume about Hartley's *Madawaska*—"the body of the other, as a harbor of warmth and human deliverance." The sense of restlessness and self-exploration that marks the figures and the portraits alike pervades the collection as a whole. Dijkstra could be speaking for the collector when he quotes Philip Evergood, another outsider championed by Kunin, in his text on the artist: "I feel the search of an artist should be for the richest and fullest of human experiences. . . . The more the artist contacts the inner qualities of people the more he will understand life and where he fits into it."

Although he is hesitant to name his favorite paintings in the collection, Myron Kunin puts Evergood's *Madonna of the Mines* (1932; fig. 37) high on his list. And Evergood's work as a whole can be said to epitomize the qualities that make this collection so unique. An outstanding, truly original artist, he developed a personal style of painting that appears to be free of outside influences. A highly idiosyncratic and socially conscious painter (he was a militant supporter of workers' rights and was jailed several times for his political activism), he was marginalized by art critics, scholars, and museums alike. He maintained his independence throughout his career nevertheless, allowing his fervent imagination to transmute everyday subjects into mystical communions with humanity.

Evergood's work is emblematic of Kunin's enduring attraction to the painting that, in his words, "reaches in, grabs your heart, and then stomps on it."[4] With a refined eye and a clear sense of purpose, Kunin has built a collection that provides a startlingly fresh perspective on American art of the first half of the twentieth century, offering not only an engaging survey of modern American art and life but also an unusually intimate and arresting glimpse into the human psyche.

4. Myron Kunin, interview by the author,
 March 24, 2005.

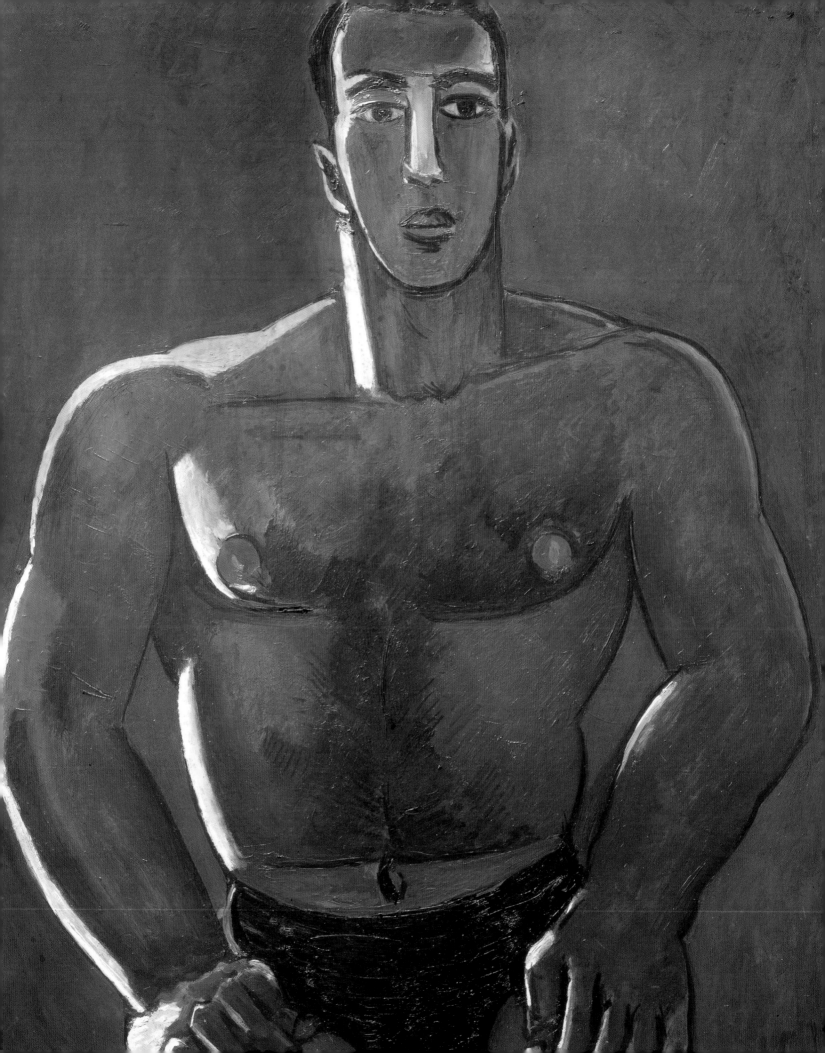

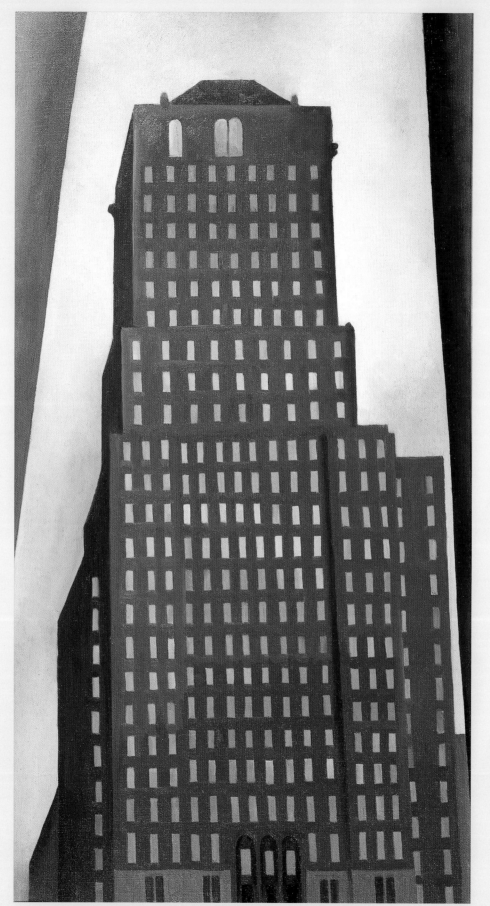

Fig. 14
Georgia O'Keeffe
Shelton Hotel, N.Y. No. 1, 1926
Cat. no. 48

Selected Works

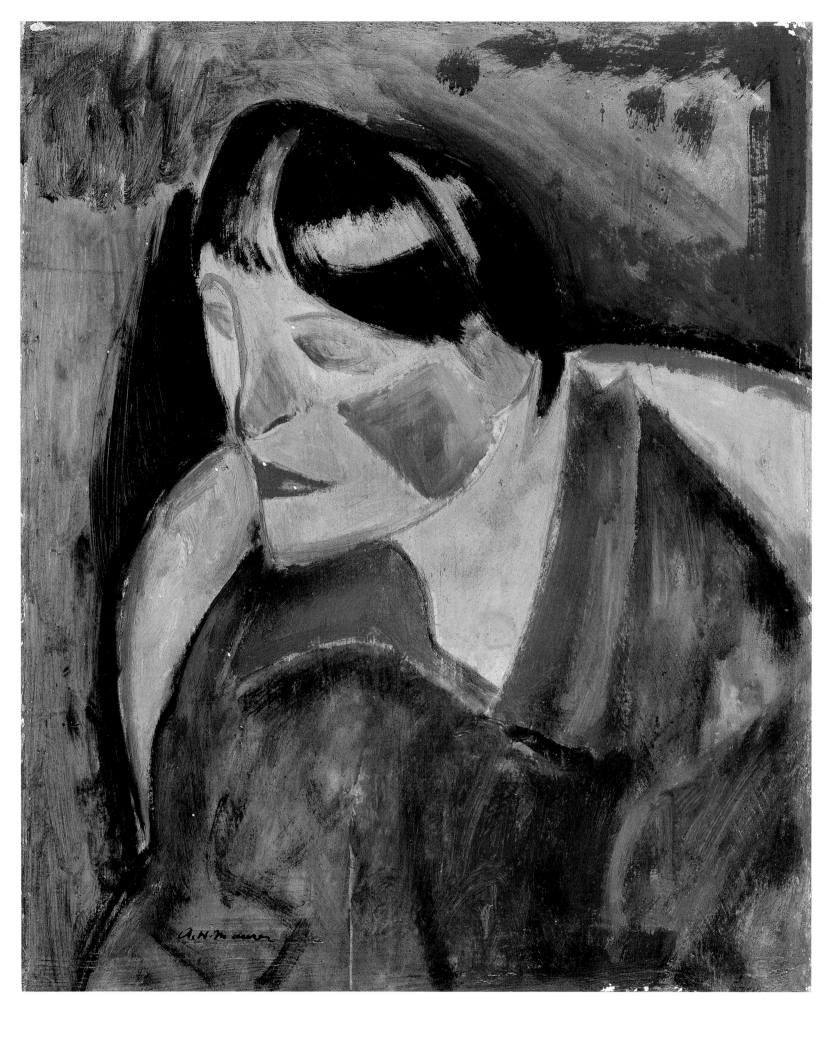

Alfred Maurer
Head of a Woman (Fauve Head), 1908

Notes

1. For a fuller account of Maurer, see William C. Agee, "The Tommy and Gill LiPuma Collection: Exploring American Art, 1906–1946," in William C. Agee and Bruce Weber, *High Notes of American Modernism: Selections from the Tommy and Gill LiPuma Collection* (New York: Berry-Hill Galleries, 2002), 23–30. See also Stacey Beth Epstein, *Alfred H. Maurer: Aestheticism to Modernism, 1897–1916* (New York: Hollis-Taggart Gallery, 2003).

Alfred Maurer, a pioneering American modernist, holds a preeminent, if still little-understood, place in our history. His fundamental importance to early modernism has been largely missed—first, because his sad biography has often overshadowed his art and, second, because his development and role in modernism have been misunderstood. He was the son of Louis Maurer, a famous Currier and Ives artist, who was a powerful and eventually overwhelming force in his son's life. The elder Maurer could never bestow recognition, much less approval, on his son's career and achievements, a constant source of despair that finally drove his son to take his own life in 1932, at the very height of his powers, another terrible chapter in an all-too-familiar story in modern American art.[1]

Maurer has often been portrayed as having two separate careers, the first as a realist and the second as a modernist, making it seem as if he came late to modernism, in a lesser role. In fact, his career was of a piece, a modernist from the start, with a deep continuity underlying his art. He was the first American modernist to settle in Paris, staying there from 1897 until 1914. At the time he was working in a realist mode, to be sure, but a style indebted to Edouard Manet, the artist viewed by many as the first modernist. Manet's influence is evident in Maurer's *Figures by the Sea* in the Kunin collection (c. 1901; fig. 16).

From the start, Maurer's art was marked by a love of color, even if at first it was in the deep, rich, darker end of the spectrum. This love of color continued to dominate his later art after he adopted the high-keyed hues of Impressionism and Fauvism. His move into a new type of color was propelled by his encounter with Leo and Gertrude Stein, sometime around 1904, through whom Maurer, like countless other Americans, was introduced to the work of Paul Cézanne, Pablo Picasso, and Henri Matisse. By 1908 paintings such as *Head of a Woman (Fauve Head)* show Maurer's assimilation of these artists' work in a personal and original manner. The painting has been linked to Fauvism, primarily because of the areas of intense red and red-orange hues. While this places Maurer as one of the first Americans to explore strong and open color, the painting does not have the overall arbitrary surface coloration of a true Fauve painting, a term overused in American art. Equally apparent and important to the painting are the strong blacks in the sitter's hair and background, a legacy of Maurer's earlier use of the hue, thus telling us just how continuous was his path to modernism. He did achieve an overall density of high-keyed color by 1914–15, as is apparent in

Fig. 15
Alfred Maurer
Head of a Woman (Fauve Head), 1908
Cat. no. 44

Alfred Maurer
Head of a Woman (Fauve Head), 1908

Landscape with Telegraph Pole, also in the Kunin collection (fig. 17). His gift for color continued throughout his career and is evident in his masterly Cubist paintings of around 1928–32, key works in the second wave of Cubism in America.

Equally telling are the sharp angles of the head, face, and shoulders in *Head of a Woman (Fauve Head)*, indicating a clear awareness of early Cubism—evidently Maurer was one of the first Americans to assimilate this influence. The bulk and solidity of the figure, outlined by the firm, strong drawing, indicate a knowledge of Picasso's massive nudes of 1908. These qualities also point to Maurer's deep interest in extending the values of Renaissance art, especially Florentine *disegno* and the art of Sandro Botticelli, which he had studied closely on a trip to Italy in 1906, values that stayed with him throughout his life. We may wonder if Matisse followed this lead, for Matisse himself made the same trip the next summer, in 1907, to assimilate and ground his art in the classical solidity of Giotto and Piero della Francesca, at a time when he feared that his Fauve painting had become too loose and unstructured. Maurer's early fusion of Matisse's color and Cubist structure, which also marked his later art, was an important process in modernism and was pioneered by other Americans—such as Morton Schamberg, Morgan Russell, Patrick Henry Bruce, and Marsden Hartley—to a far greater extent than by the French, with the works of the Americans predating even the Orphist paintings of Robert and Sonia Delauany.

Although less known today, Maurer was widely admired and respected earlier in his career and was a guiding presence in Paris for visiting artists such as Hartley and Arthur Dove. Continued and careful study of the fullness of Maurer's art will reveal him, once more, as the commanding artist he was. Hans Hofmann had it right when he said in 1950 that Maurer was forerunner of a "true and great tradition" still being defined.[2]

William C. Agee

2. Agee, "Tommy and Gill LiPuma Collection," 30.

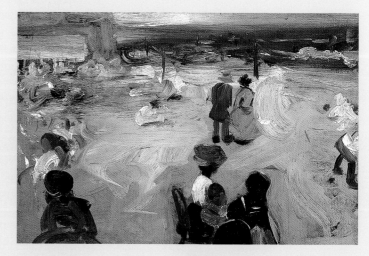

Fig. 16
Alfred Maurer
Figures by the Sea, c. 1901
Oil on canvas
14 x 20 1/2 in. (35.6 x 52 cm)
Collection of Curtis Galleries, Inc., founder
Myron Kunin

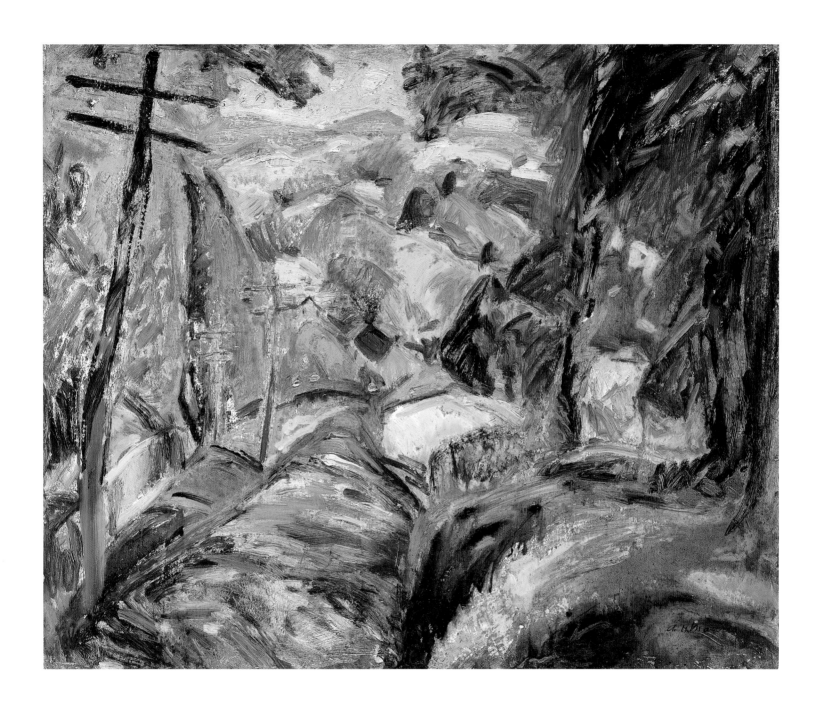

Fig. 17
Alfred Maurer
Landscape with Telegraph Pole, 1915
Oil on board
18 x 21 1/2 in. (45.7 x 54.6 cm)
Collection of Curtis Galleries, Inc., founder
Myron Kunin

Stuart Davis
Ebb Tide—Provincetown (Man on the Beach), 1913

Done in the summer of 1913, when the artist was not yet twenty-one, this painting tells us of the immediate impact the famous Armory Show of February 1913 had on American artists, including the young and precocious Stuart Davis. It was Davis's first large and important landscape painting, a decisive shift from the gritty urban realism he had been exploring for the past three years under the guidance of Robert Henri, a teacher of enormous influence on an entire generation of emerging artists. Although Henri had been of monumental importance for him, Davis knew that he had to expand his painterly horizons beyond Henri's urban focus. At the Armory Show, Davis found a wealth of possibilities that opened modernist practice to him. He responded particularly to the work of Paul Gauguin, Vincent van Gogh, and Henri Matisse, artists who stayed with him throughout his life. But there was more, and Davis, always systematic in his approach and practice, seemed to understand that he needed to explore a wide range of newer art.[1]

He also seemed to understand that he had to expand his sense of the world beyond the streets of New York. We think of Davis as the quintessential hip New York artist, and this is true to a large extent. But in fact the sea and shore were just as important to him, and from 1913 to 1940 he spent extended periods on the coast of Massachusetts, first in Provincetown, then, after 1914, in Gloucester, both longtime centers for artists. Henri and John Sloan, another important mentor for Davis, were both good seascape painters, which would not have escaped Davis. It is apparent that the wide expanses of sea and sand in Provincetown had an immediate and liberating effect on him. *Ebb Tide—Provincetown (Man on the Beach)* is the largest painting, in scale if not in size, that Davis had attempted to date, and through its flowing shapes and rich coloration, he introduced into his art a broader, more open and expansive type of painting. The drawing in the painting indicates some residue of his exposure to Gauguin, van Gogh, and even Edvard Munch at the Armory Show. The essence of the painting, however, is an homage to the great American romantic, mystic painter Albert Pinkham Ryder, whose work had been shown in depth at the Armory Show. The picture is thus the first of Davis's several ongoing critiques of ranking masters, in which he at once absorbed, challenged, and "corrected" or "improved," via his own experience and interpretation, on the work of artists he admired and respected, among them van Gogh, Matisse, Pablo Picasso, and Piet Mondrian. In *Ebb Tide*, however, Davis looked to an American artist, whose haunting and darkened reveries of heavy, thick paint have inspired subsequent American artists from Marsden Hartley

Notes
1. For a full account of the six decades of Davis's art and life, see Lowery Stokes Sims et al., *Stuart Davis: American Painter*, exh. cat. (New York: Metropolitan Museum of Art, 1991). The Davis catalogue raisonné, with essays by William C. Agee and Karen Wilkin, is forthcoming from Yale University Press.

Fig. 18
Stuart Davis
Ebb Tide, Provincetown (Man on the Beach), 1913
Cat. no. 17

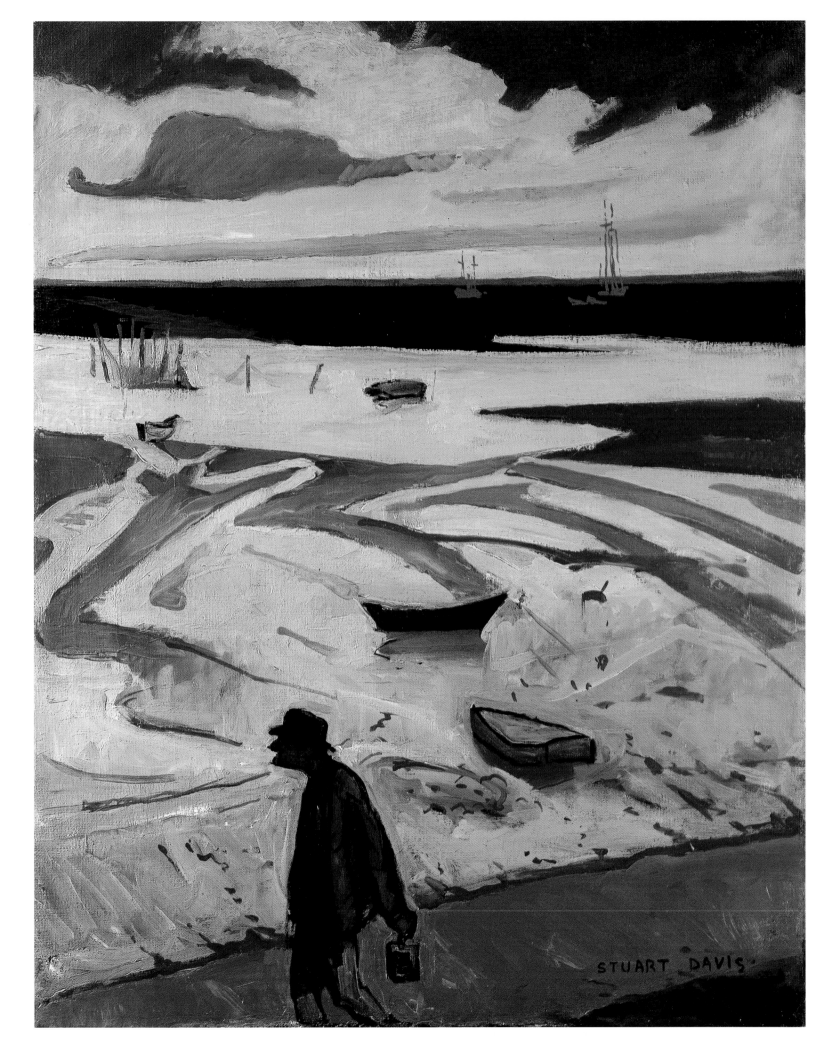

Stuart Davis
Ebb Tide—Provincetown (Man on the Beach), 1913

and Arthur Dove to Jackson Pollock and Bill Jensen. Davis would have seen Ryder's *Moonlight Marine* (Metropolitan Museum of Art, New York) and *Moonlit Cove* (Phillips Collection, Washington, D.C.) at the Armory Show, for the mood and facture of these works permeate his painting.

After 1914 Davis's paintings were bright, airy, and syncopated like the jazz he loved and admired all his life. But here he explored, as Ryder had done, the dark side of the soul, literally the ebb tide of the persona, a symbolist excursion into the very being of man, who here is truly but a shadow of himself. The psychological tension in the painting, manifest in the sky and sea, had its precedents in Davis's urban paintings, such as his 1912 *Self-Portrait* (fig. 20), which reflect the lurking dangers of the modern city. In *Ebb Tide* these sinister forces are translated into the dark forces of nature, of the cosmos itself, with man, earth, sea, and sky joined immutably. The painting could in turn be a stage setting for a drama by Fyodor Dostoyevesky, Edgar Allan Poe, Henrik Ibsen, John Millington Synge, or August Strindberg, realist and symbolist writers whose works Davis had read at Henri's urging. It is a unique painting for Davis, but it tells us of the complexity that defined him throughout his life, even as he became one of America's greatest artists.

William C. Agee

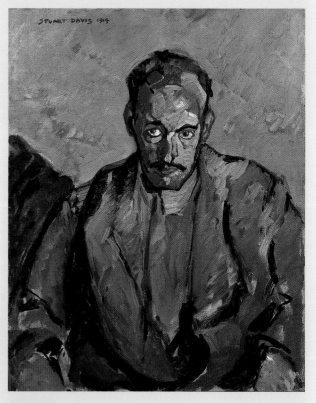

Fig. 19
Stuart Davis
Portrait of a Man, 1914
Cat. no. 18

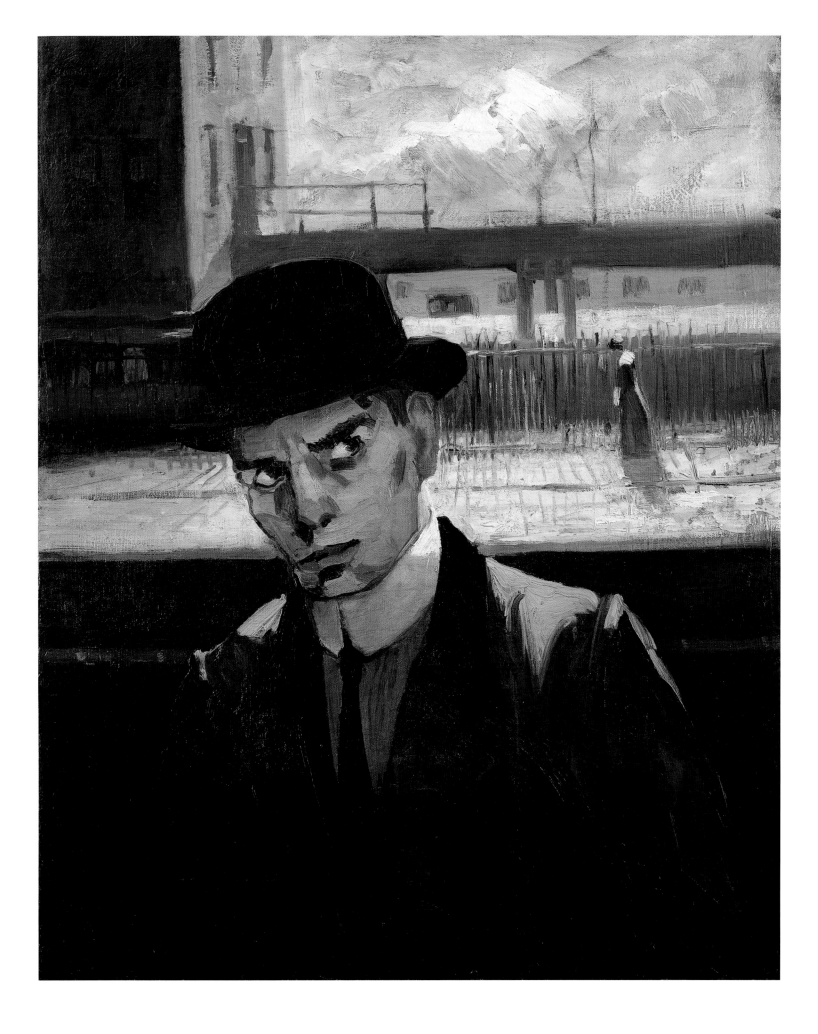

Morton L. Schamberg
Figure A (Geometrical Patterns), 1913

Fig. 22
Morton L. Schamberg
Figure A (Geometrical Patterns), 1913
Cat. no. 59

Despite his early death in the flu pandemic of 1918, Morton Schamberg was a major American artist who made significant contributions to modernism in this country. He is often cited only as a promising artist, but this assessment overlooks the considerable body of art that he left as his legacy, including *Figure A* of 1913 (*Figure* was the title he gave the painting, which has since come to be known as *Geometrical Patterns*).[1] Schamberg was born, educated, and trained in Philadelphia, first at the University of Pennsylvania, where he studied architecture, then at the Pennsylvania Academy of the Fine Arts (virtually the birthplace of modernism in the United States), where he met and studied with his close friend Charles Sheeler. They traveled together in Europe, studying early Renaissance painting in Italy and Impressionism and Postimpressionism in Paris. The influence of Paul Cézanne, Vincent van Gogh, Paul Gauguin, André Derain, Georges Braque, Pablo Picasso, and Henri Matisse was readily discernible in Schamberg's art of 1908–12.

The Armory Show of 1913 was a decisive event for both Schamberg and Sheeler, as it was for so many American artists. They were particularly struck by Matisse's art in the exhibition, especially *The Red Studio* (Museum of Modern Art, New York) of 1911, both for its color and its design, which told them that a painting could be as "arbitrarily conceived as an artist wished."[2] In addition, they could study Cubist structure in greater depth in the work of Picasso, Braque, and others. At the Armory Show, Schamberg had also paid attention to Matisse's monumental sculpture *Back I* (Museum of Modern Art, New York), surely the source for *Figure A*. Schamberg's painting is the first in a series of three large figures; the last, *Figure C* of 1914, which has a more complex Cubist composition, is also in the Kunin collection (fig. 23). Schamberg would have been drawn to Matisse's sculpture because its mass and bulk continued the tradition of the monumentality of Cézanne's late Bathers, iconic images for younger artists, also evident in *Two Seated Figures* (1910; cat. no. 74) by Max Weber.

In turn, Schamberg's figures harked back further, to the Italian Renaissance tradition of massive figures, both sculptural and painted, that he and Sheeler had come to love on their European trips. The work of Giotto, Piero della Francesca, and Michelangelo, artists whose work Matisse had also studied on his trip to Italy in the summer of 1907, certainly informs Schamberg's *Figure A*. For Schamberg and Sheeler, as well as for many other artists, the Italian Renaissance remained as the highest standard of

Notes
1. For a full account of Schamberg's art and life, see William C. Agee, *Morton Livingston Schamberg (1881–1918)* (New York: Salander-O'Reilly Galleries, 1982). See also William C. Agee, *Morton Livingston Schamberg: The Machine Pastels* (New York: Salander-O'Reilly Galleries, 1986).
2. Charles Sheeler, cited in Agee, *Morton Livingston Schamberg (1881–1918),* 7.

Fig. 21
Morton L. Schamberg
Painting IV, 1916
Oil on canvas
24 x 20 in. (61 x 50.8 cm)
Collection of Curtis Galleries, Inc., founder Myron Kunin

Morton L. Schamberg
Figure A (Geometrical Patterns), 1913

achievement, and they sought for their own art the same weight, solidity, and probity. Far from wishing to discard the past, as we so often think they sought to do, modern artists frequently sought to emulate and to maintain its standards, values, and qualities.

The color in *Figure A*—and in *Figure C*—identifies Schamberg as an early and important member of the group of artists involved in the Orphist-Synchromist drive to fuse color and Cubism, to create works in which intense hues became virtually autonomous structural elements. The reds surely were inspired by Matisse's *Red Studio*, but the sequencing within them, their gradations from light to dark, shows an early mastery of long-standing color principles developed in the nineteenth century. The reds are contrasted with gradations of rich blues, which define the space, making it as tangible and dense as the figure itself. Color usage was also at the heart of Schamberg's last works, the machine works of 1916 such as *Painting IV* (fig. 21), also in the Kunin collection (which depicts a textile machine, not a camera flashlight, as previously thought), thus distinguishing them from related works by Marcel Duchamp and Francis Picabia.

William C. Agee

Fig. 23
Morton L. Schamberg
Figure C, 1914
Oil on canvas
28 x 16 in. (71.1 x 40.6 cm)
Collection of Curtis Galleries, Inc., founder
Myron Kunin

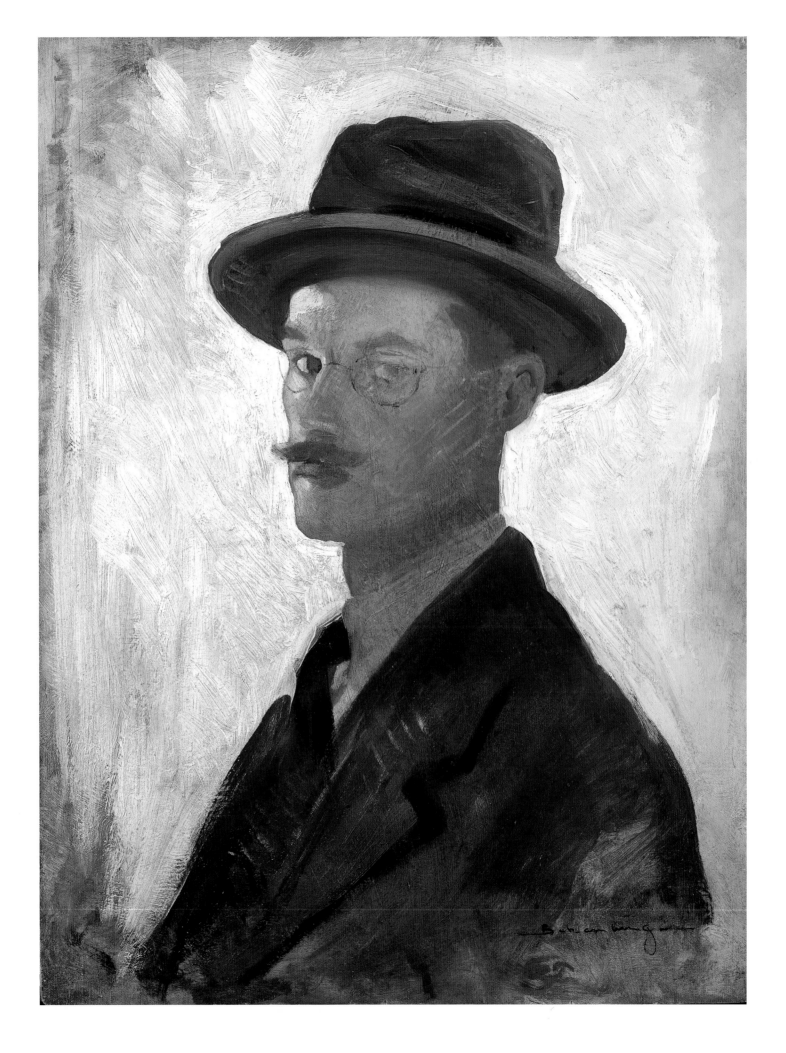

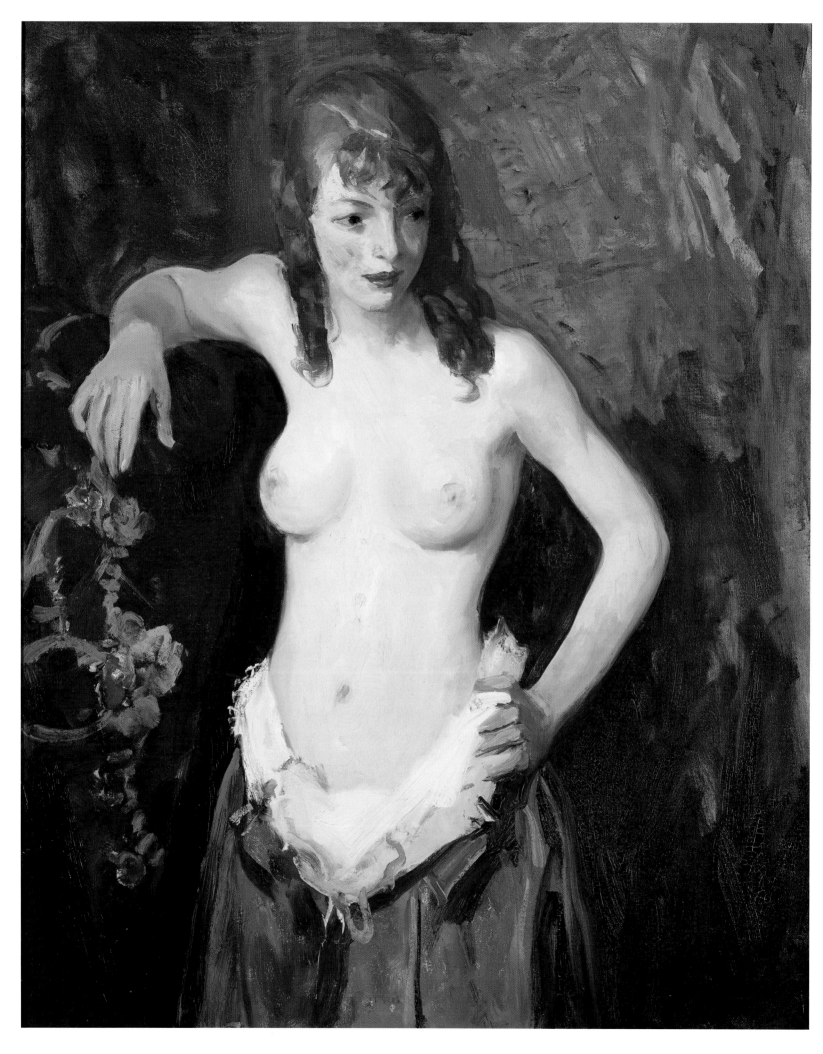

Robert Henri
Edna Smith (The Sunday Shawl), 1915

Notes
1. Robert Henri, *The Art Spirit,* new ed. (New York: Lippincott, 1939), 119.
2. Quoted in William Innes Homer, *Robert Henri and His Circle,* rev. ed. (New York: Hacker Art Books, 1988), 263.
3. Henri, *The Art Spirit,* 194.

"The exterior of the model is not the model," Robert Henri admonished his students in *The Art Spirit.*[1] Later, in a diary entry, he observed: "Work quickly. Don't stop for anything but the essential . . . make the draperies move, don't let them stop. . . . It is the spirit of the thing that counts."[2] The extraordinary nudes the artist painted in the later years of his life serve as a vivid testimonial to the validity of these remarks. *Edna Smith (The Sunday Shawl)* is a prime example. It captures Edna Smith, one of two models Henri returned to repeatedly at this time, in a remarkably unstudied moment. Her attention, it would seem, has just been drawn to someone else in the room in which she is undressing. Despite her nakedness, she is clearly at ease and unself-conscious, unconcerned that her loosened skirt might be about to slip from her loins. Her face is fresh and rosy—her expression that of someone who takes the flawless proportions of her youthful body entirely for granted.

The casual nature of her pose—one elbow on an armoire, the other angled outward, her hand firmly planted on her hip—would have been seen, at the time Henri painted her, as shockingly masculine in its self-confident nonchalance. Yet this young woman is also the very image of the all-American girl next door. But all-American girls were not supposed to be seen in the nude. They were expected to carry parasols and lilies and cover their entire bodies with sparkling white dresses. In 1915 (and far into the future), women who were both beautiful and self-confident were habitually portrayed as vampires, creatures like Theda Bara (the supposed personification of "Arab Death"), who were thought to be ready at a moment's notice to drag men into a quagmire of sin and destruction. Instead, Henri here presents us with a young woman, a redhead no less, who, though naked, is as fresh and charming as a debutante. Her eyes, even if dark as coals, are not the burned-out embers of an unthinking, instinct-driven animal. Instead they are steady and open, penetrating in the frank and attentive immediacy of their gaze. But was this a true portrait of Edna Smith? Henri knew how to answer such questions as well: "What you see is not what is over there, but what you are capable of seeing. It is a creation of your own mind, not the model. The model is dependent on your idea of her."[3]

Henri—painting rapidly, no doubt—also captured the young woman's hair in a rush of forward motion as if she had just casually turned her head toward that other person sitting to her left, who has become the focus of her attention, her easy manner once again evidence of the lack of embarrassment with which she occupies her space.

Fig. 25
Robert Henri
Edna Smith (The Sunday Shawl), 1915
Cat. no. 36

Robert Henri
Edna Smith (The Sunday Shawl), 1915

"Paint the hair in accord with the model's gesture—a symphony with other forms in the body. . . . Gestures of the hair can be taken in harmony with the person—which will be an interesting expression of action," the artist had instructed his students a few years before he painted this image.[4]

Thus, in confronting us with a young woman both sexually aware and fresh as the newborn day, Henri's painting presented its viewers with as shocking a provocation to accepted mores as Marcel Duchamp's *Fountain* (1917) would be a few years later. But it does so in a much less melodramatic fashion. The shocking truth Henri forced his viewers to confront is that this comfortably naked girl is as "cleanly" American as the most innocent of Henry James's vivacious heroines. Yet unlike Daisy Miller and her sisters of earlier decades, she is not an innocent abroad destined to be gobbled up and destroyed by cynical European sophisticates, nor, conversely, is she ready to gobble them up instead in the manner of Undine Spragg, the beautiful but terminally vulgar vampire-heroine of Edith Wharton's *Custom of the Country*, a novel that had been published just two years earlier.

This woman is a threat of a different nature. By being not at all ashamed to reveal herself to our gaze, this self-possessed woman obliterates centuries of manipulative male fantasies about "helpless" virgins and "unnatural" whores. Henri loved the creative energy of America's women. He did not fear their independence: "A young girl may come into a room and with her thoroughly unconscious gesture bring animation and a sense of youth, health and good will. . . . There is a need within her to transform all environment *[sic]* to her own likeness. Her whole body, her look, her color, her voice, all about her is in service and is unconsciously ordered to express and spread the influence of the song that is in her."[5]

Because in this portrait Henri was able to capture so well the erotic spontaneity of women such as Edna Smith, this is a genuinely revolutionary image in the canon of American painting. The sentiments it conveys are gloriously offensive to all doctrine. Instead it is a true celebration of life and human freedom—and yes indeed, it also happens to be a magnificent work of art.

Bram Dijkstra

4. "The Teachings of Robert Henri: The Alice Klauber Manuscript," in Bennard B. Perlman, *Robert Henri: His Life and Art* (New York: Dover, 1991), 141.

5. Henri, *The Art Spirit*, 179.

Fig. 26
Robert Henri
Edna Smith (The Sunday Shawl), 1915 (detail)
Cat. no. 36

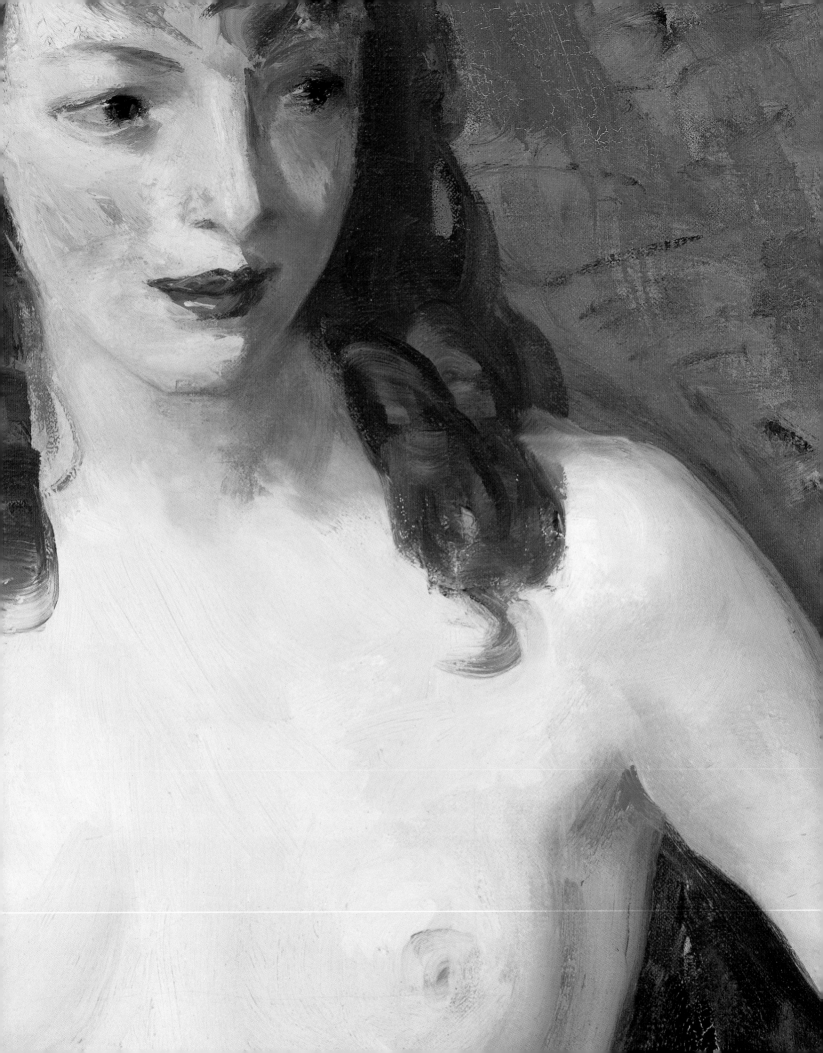

Arthur B. Carles
Nude Reclining, 1921

Although only six years separate Arthur B. Carles's *Nude Reclining* and Robert
Henri's *Edna Smith (The Sunday Shawl)* (fig. 25), they are worlds apart when it comes
to the manner in which they treat the subject of the female nude. Henri's work, though
brilliantly painted, is fairly conventional in its overall approach as well as in its insis-
tence on giving the canvas a "finished" look. Carles's treatment, in contrast, is that
of an artist in transition to modernism: the upper part of his canvas and the torso of
his subject are rendered in a relatively free manner whose innovative qualities are
partially obscured by the artist's traditional use of shading and coloration. The bottom
third of the canvas, however, crackles with the slash and splash of paint we associ-
ate with the work of the Abstract Expressionists of the post–World War II era—and in
particular that of Willem de Kooning, who, as Barbara Wolanin has pointed out in her
1983 study of Carles's work, freely acknowledged his influence.[1] Carles had spent
considerable time in Paris between 1908 and 1910, and participated—along with
figures such as Arthur Dove, Marsden Hartley, John Marin, Alfred Maurer, and Max
Weber—in the exhibition *Younger American Painters* at Alfred Stieglitz's gallery, 291,
in March 1910. In 1912 Stieglitz further enhanced Carles's modernist credentials by
giving him his first solo exhibition anywhere.

Yet notwithstanding the modernist elements to be found in the artist's work, his
renderings of the figure are as emotionally mired in nineteenth-century concep-
tions of the feminine as those of de Kooning would also continue to be, proving once
again that an artist's adoption of modernism is by no means in itself a reflection of
progressive thinking. Carles's *Nude Reclining* of 1921 is a case in point. The way the
artist posed his figure is characteristic of standard late nineteenth-century Paris Salon
fare. He placed her (brilliantly rendered and strikingly three-dimensional) body on
a fiery red cloth that serves to give it still-life qualities—as if she were no more than
a delectable fruit in a fancy greengrocer's window. There she is left lying supine and
immobile, as if paralyzed and incapable of any form of rational, independent action.
Moreover, as is characteristic of virtually all of Carles's renderings of the female
nude, her face is obscured—one is tempted to say obliterated—denying her any
individuality as a person. The artist further enhanced this woman's apparent help-
lessness by scratching in a few strokes of generic paint where her hand should be.
Carles, as nearly all his figure paintings demonstrate, had a technical block against
rendering what his contemporary Fats Waller would have called the "pedal extremi-
ties" of his subjects. In fact, Carles's block included extremities of all sorts, and by

Notes

1. Barbara A. Wolanin, *Arthur Carles:
Painting with Color* (Philadelphia:
Pennsylvania Academy of the Fine
Arts, 1983), 133.

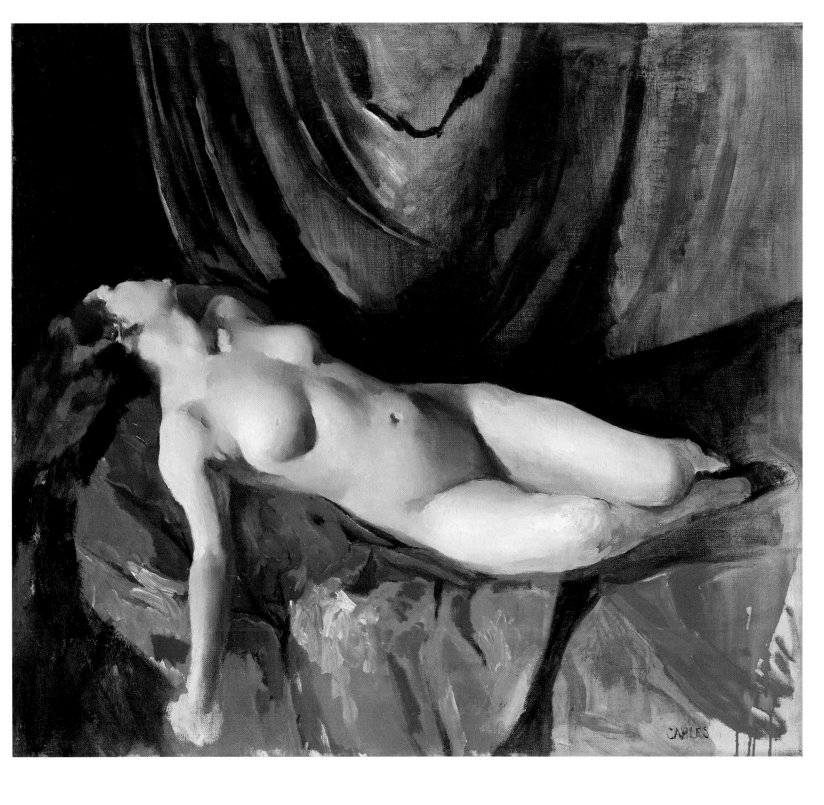

Fig. 27
Arthur B. Carles
Nude Reclining, 1921
Cat. no. 12

Arthur B. Carles
Nude Reclining, 1921

making this woman's hand as well as her feet disappear as if in a cloud of dust, he succeeded only in further emphasizing her emphatic lack of agency.

Still, even if the social ideology behind Carles's *Nude Reclining* continues to reflect the work of such stars of the firmament of high bourgeois art as Alexandre Cabanel, William-Adolphe Bouguereau, and Carolus-Duran, there can be little doubt that, as a painterly tour de force, this work is nearly on the same level of achievement as Henri's *Edna Smith*. The artist was able to utilize the bravura style of painting he had learned from an older generation (William Merritt Chase, John Singer Sargent, and, almost certainly, Henri as well) in such an innovative fashion that he succeeded brilliantly in bridging the worlds of academe and modernism. Unfortunately his stylistic innovations failed to obscure the mind of the artist behind the art.

Bram Dijkstra

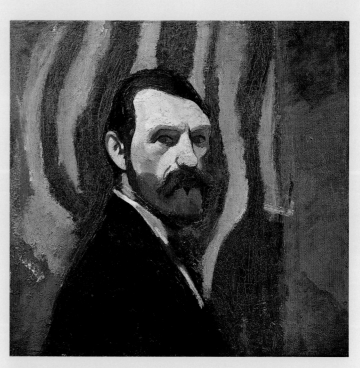

Fig. 28
Arthur B. Carles
Self-Portrait in Front of Striped Cloth,
c. 1915
Cat. no. 11

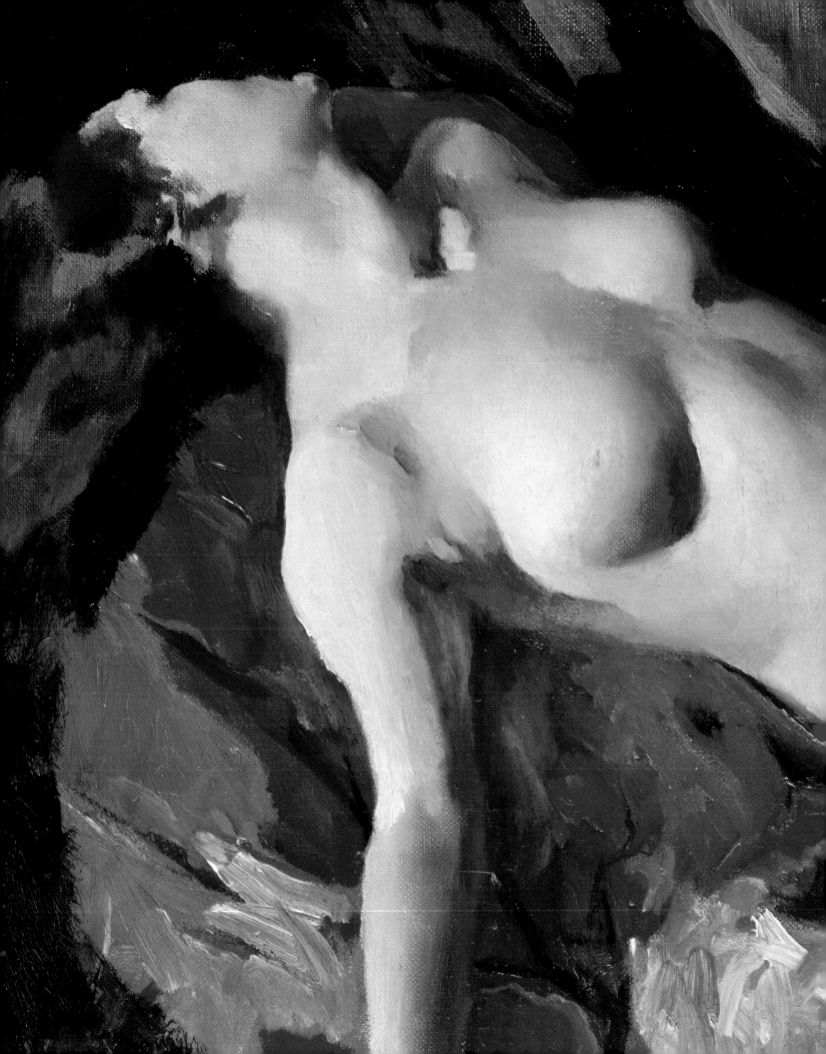

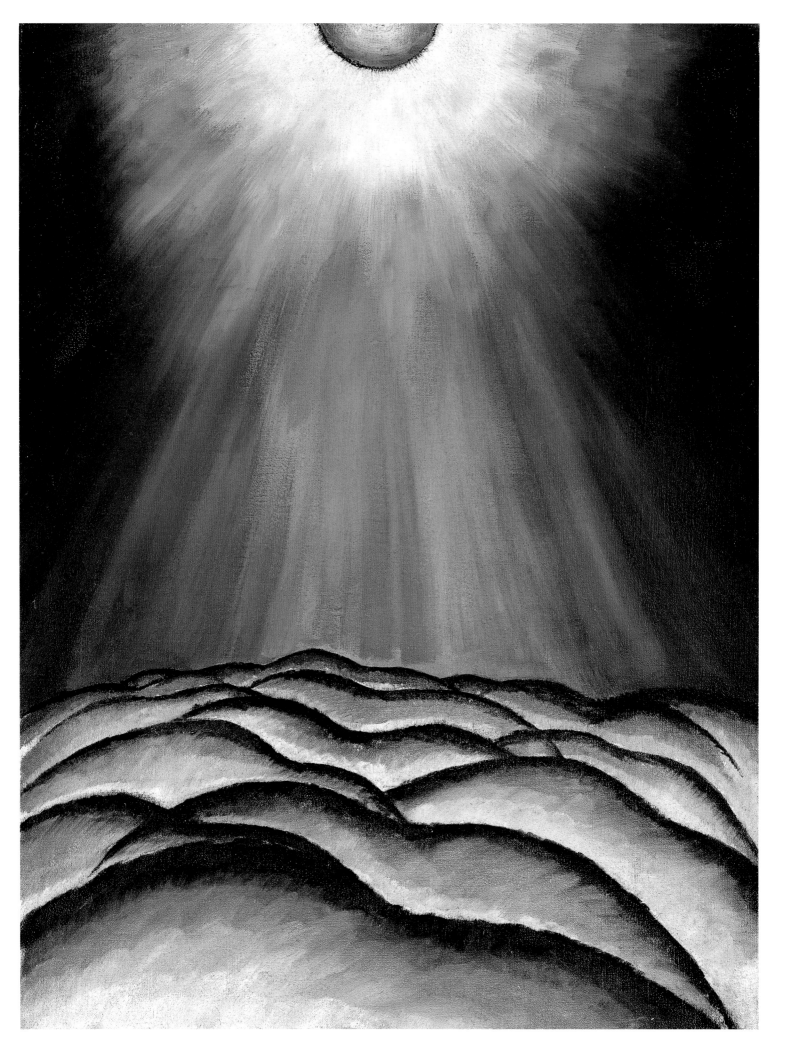

Arthur Dove
Moon and Sea II, 1923

Notes

1. If in fact there was a first version, its location is not known.
2. Arthur Dove to Alfred Stieglitz, October 24, 1923, in Ann Morgan, ed., *Dear Stieglitz, Dear Dove* (Newark: University of Delaware Press, 1988), 97–98.
3. Ibid., 98.

This small and apparently modest painting marks a turning point in the art and life of Arthur Dove, one of this country's best and most beloved modernists. There is an almost identical version, *After the Storm, Silver and Green (Vault Sky)* (State Museum of New Jersey, Trenton), a title perhaps more descriptive of the source and the essence of the work. The paintings were done in the late fall of 1923, shortly, if not immediately, after a fierce gale had passed over the waters of Long Island Sound on October 23 and 24.[1] The event was vividly recorded by Dove in a letter written to his mentor and champion, Alfred Stieglitz, during the course of the storm in the early morning hours of the twenty-fourth.[2] Dove and his new companion, Helen "Reds" Torr, had weathered the storm on their new boat, the *Mona*, while moored in Manhasset Bay after a perilous journey from the Hudson River. The storm had severely tested the boat, as well as the new partnership of Dove and Reds, but they had survived, stronger and with a new "unity of interest." Dove related to Stieglitz that he had been "trying to memorize this storm all day so that I can paint it. Storm green and storm grey." That morning Dove added a postscript: "Storm breaks. . . . What a relief."[3] It is precisely that "relief" and its aftermath that Dove painted, rather than the storm itself.

The painting fairly exudes a calm and serenity that speak volumes about Dove. He had long sought his independence—first from critical and unsupportive parents; then, more recently, from the backbreaking labor of trying to run a farm in Westport, Connecticut; and, finally, from an unhappy marriage. Life on the water, which he had always loved, seemed to be the answer to weathering his personal struggles, "the storm," we might say, but only after the final test of a storm itself, for nothing ever came easily for Dove. He felt a new sense of freedom after the death of his oppressive father, and he, the boat, and his relationship with his new partner seemed to have passed with flying colors; he could now look forward to calm sailing, as the mood of the painting seems to suggest. So he thought, but his life was never to be without hardship and struggle.

Moon and Sea II and its companion also mark the passing of another storm, the crisis over Dove's productive life as an artist. Dove had a difficult time getting to his talent. After an initial surge of important and original work from 1908 through 1912, he had done little for almost ten years, and even Stieglitz wondered if he would ever paint again. He seemed blocked by his oppressive father, and he was so determined to establish his independence, both financially and artistically, that he had little time or

Fig. 30
Arthur Dove
Moon and Sea II, 1923
Cat. no. 23

Arthur Dove
Moon and Sea II, 1923

energy left for painting.[4] He started again, fitfully, in 1922, but it was really with *Moon and Sea II* that Dove resumed painting, fully committed and fully believing in himself.

There is a new confidence and assurance in the painting, and its open, symmetrical composition possesses a lyrical simplicity that often marked the best of Dove's art, then and later. It is like a private icon, a personal altar—in the vault sky—before the vastness of nature, the cosmos itself, with which Dove felt a new "unity of interest." While it is virtually a private journal, the image of moon over the water (although here it is easy to read the setting as actually above the clouds, in another domain altogether) has a long tradition. It relates to the whole history of romanticism, from Caspar David Friedrich to the sun and moon images of Vincent van Gogh, an artist Dove deeply loved, and extended to Albert Pinkham Ryder and even to Winslow Homer in his remarkable painting in the Kunin collection, *Cape Trinity, Saquenay River, Moonlight* (1904/1906–7). Dove's exploration of higher realms also parallels the famous cloud and sky photographs by Stieglitz, the Equivalents, begun the same year. The image recurred throughout Dove's art, appearing in another painting in the Kunin collection, *The Moon* (1941; fig. 31). The centralized moon looks ahead to the circle paintings of Kenneth Noland, done in the late 1950s and early 1960s and also filled with cosmic references, as does the beautiful, subtle coloration.[5] Dove's use of silver-grays ranks with that of James McNeill Whistler and, later, Jackson Pollock.

William C. Agee

4. For more on Dove's art and life and his relationship to Stieglitz, see William C. Agee, "Arthur Dove: A Place to Find Things," and the other essays in Sarah Greenough et al., *Modern Art and America: Alfred Stieglitz and His New York Galleries* (Washington, D.C.: National Gallery of Art, 2000).

5. For the Dove and Noland connection, and the development of the circle, see William C. Agee, *Kenneth Noland: The Circle Paintings* (Houston: Museum of Fine Arts, 1996).

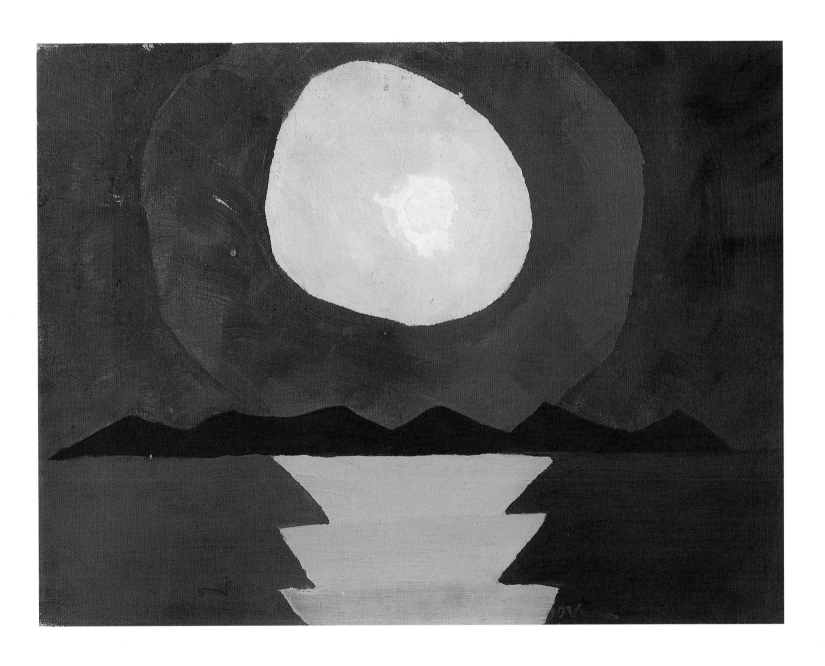

Fig. 31
Arthur Dove
The Moon, 1941
Encaustic on canvas
12 x 16 in. (30.5 x 40.6 cm)
Collection of Curtis Galleries, Inc., founder
Myron Kunin

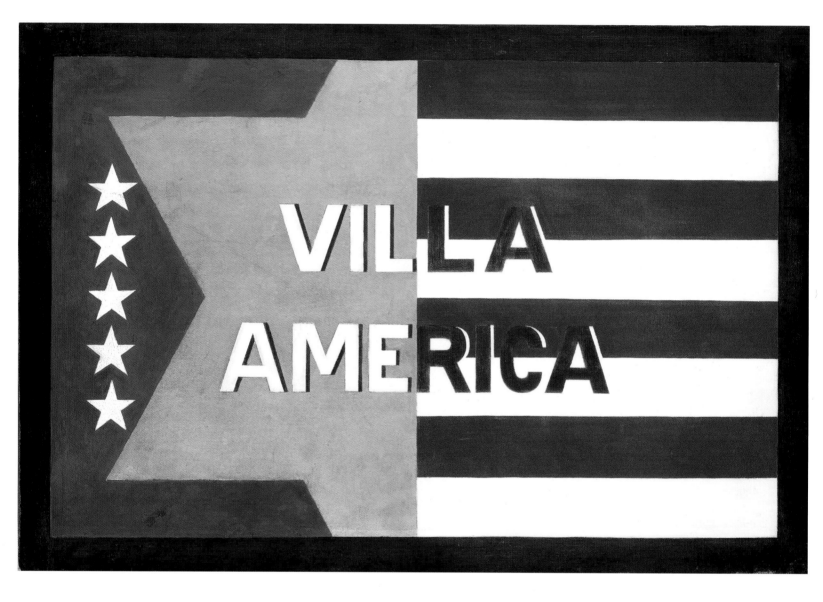

Fig. 32
Gerald Murphy
Villa America, c. 1924
Cat. no. 45

Gerald Murphy
Villa America, c. 1924

Gerald Murphy painted for only a decade. Of the sixteen paintings that are known from photographs and exhibition reviews, only eight works by him survive. The Kunin collection includes two, each expressing a different side of Murphy's personality and life abroad.

Murphy and his wife, Sara, lived in France from 1921 to 1932. In their thirties when they arrived in France, they had three young children and enough money to live comfortably. They also had exquisite taste and style—evident in their friends, their parties, and their homes. Their circle of friends included Pablo Picasso and Fernand Léger and, on the American side, Cole Porter, Scott Fitzgerald, John Dos Passos, Ernest Hemingway, Archibald MacLeish, Philip Barry, and Dorothy Parker. Not just their friendships but also their American-style parties have become legendary.[1] Murphy made elaborate cocktails, Sara served waffles for breakfast and corn on the cob for lunch, and the children sang Negro spirituals after dinner. The Murphys were "the epitome of the transatlantic chic," wrote Dos Passos. "Americans were rather in style in Europe in the twenties. Dollars, skyscrapers, jazz, everything transatlantic had a romantic air."[2]

The Murphys hosted their friends in a fourteen-room house in Antibes, on the French Riviera. It was an older stucco structure surrounded by terraced gardens that they had stylishly modernized. *Villa America* they called it. Murphy, who had taken up modern painting in France, created a witty signboard to identify the house at the entrance to the driveway. About fourteen by twenty-one inches in size, his sign was as flat and schematic as a modern poster or advertisement. His red and white stripes and blue field of stars referenced the American flag as well as the French tricolor. The division of the picture into two fields may also signify the family's bicontinental lifestyle. The five white stars stand for the five members of the family; the big star, painted in gold leaf, an expensive material, may have been inspired, William C. Agee has suggested, by the Byzantine art the Murphys saw on a summer trip to Venice in 1923.[3]

Agee was also the first to note the painting's wordplay. By painting some of the letters of VILLA AMERICA in white and others in black, and dividing them down the middle, he created two phrases: VIL AME and LA RICA, the first a French phrase, the second a Spanish one. Agee read them as references to the bountiful character and beauty of

Notes

1. For biographical information about the Murphys, see Calvin Tomkins, *Living Well Is the Best Revenge* (New York: Viking, 1971); Honoria Murphy Donnelly and Richard N. Billings, *Sara and Gerald: Villa America and After* (New York: NYT Times Books, 1982); and Amanda Vaill, *Everybody Was So Young: Gerald and Sara Murphy, a Lost Generation Love Story* (Boston: Houghton Mifflin, 1998). See also Linda Patterson Miller, ed., *Letters from the Lost Generation: Gerald and Sara Murphy and Friends* (New Brunswick, N.J.: Rutgers University Press, 1991).

2. John Dos Passos, *The Best Times: An Informal Memoir* (London: Trinity Press, 1966), 146, 153.

3. William C. Agee, "Gerald Murphy, Painter: Recent Discoveries, New Observations," *Arts Magazine* 59 (May 1985): 81–89.

Gerald Murphy
Villa America, c. 1924

Villa America, *l'âme* being French for soul and *la rica* Spanish for richness. I suspect, however, that Murphy, who loved linguistic games, was being much more ironic and droll. *Vil âme* translates quite literally as vile or depraved soul and *la rica* means the rich one. Knowing how amusing Murphy could be, I read these subtexts as self-referential, as poking fun at his own wealth and lavishly "decadent" parties. He may also have been mocking his native land, known for its excessive wealth and for exporting such "depraved" art forms as jazz and the Charleston.

Villa America is Murphy at his wittiest and most charming. It conveys the pleasure he took in his family, in his home, and in the creative life he and Sara led as Americans abroad. *Doves* (1925; fig. 33), a much larger painting, conveys Murphy's serious ambitions and success as a modern painter. Although Murphy had very little artistic training—a few lessons with the Russian avant-gardist Natalia Goncharova and a close friendship with Léger—he was a remarkably quick study in modernist principles. *Doves* reflects his mastery of Synthetic Cubism and early theories of abstraction and fragmentation. Perhaps, too, he was thinking about Surrealism; the three birds, with their perfectly circled eyes, could be a metaphor for dreamlike states and primordial innocence.

The painting was inspired by an actual incident. Murphy had seen doves nestled into the columns and niches of an old chapel in Genoa, a common sight in Europe. He used architectural details, seen from different angles, to structure his painting and frame the three birds. The profile of an architrave along the left-hand side is repeated in a front corner view in sunshine in the upper left and at dusk in the upper right. The references to columns are more brightly lit Ionic volutes and flutings at the left and a shadowy column base at the right. Murphy, known by his family and friends as a perfectionist, built the painting as if it were a fine piece of furniture. His immaculate edges, flat planes of soft colors, and rhymed sequencing of rounded and linear forms give the painting its elegance and modernity. An inner black frame of paint, a stylization Murphy favored, sets off the composition from its immediate environment. In a notebook of ideas for paintings, Murphy wrote of *Doves*: "profile shapes, tender colors, sure graceful forms, ghosted."[4] His handwriting was as meticulous and clear as his painting.

The Murphy family left Europe in 1932, their life clouded by personal hardships. The Depression, and the death of Murphy's father in 1931 and that of his mother five months later, put Mark Cross, the family business, into jeopardy. Murphy returned to New York to manage the company. Then, tragically, his two sons died as teenagers, one of meningitis in 1935, the other of tuberculosis in 1937. During these heartbreaking years Murphy found neither the time nor the will to paint. His short but brilliant decade as a painter had ended.[5]

Wanda M. Corn

4. I am indebted here to Rick Stewart, *An American Painter in Paris: Gerald Murphy* (Dallas: Dallas Museum of Art, 1986), 19. See also William Rubin, *The Paintings of Gerald Murphy* (New York: Museum of Modern Art, 1974), 17–18, 34–35.
5. For further thinking about Murphy, see chapter 2 in my own *The Great American Thing: Modern Art and National Identity, 1915–1935* (Berkeley and Los Angeles: University of California Press, 1999).

Fig. 33
Gerald Murphy
Doves, 1925
Cat. no. 46

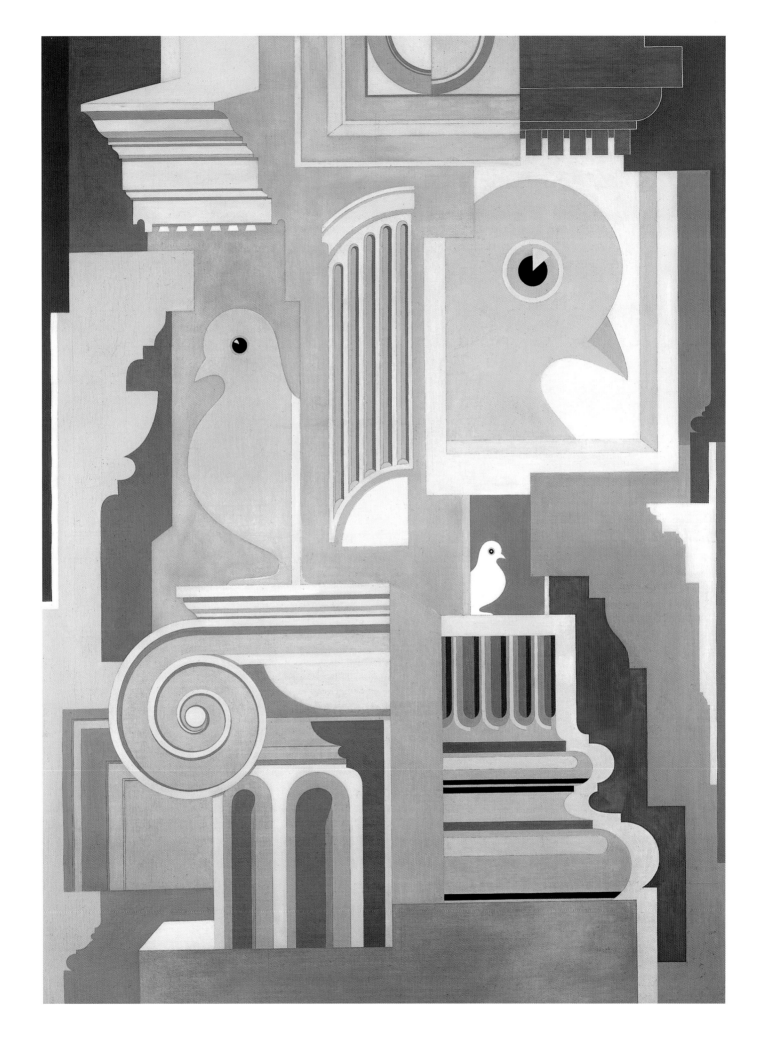

Georgia O'Keeffe
Green-Grey Abstraction, 1931

Although not as well known as other, more iconic images of the period, this painting is among Georgia O'Keeffe's most beautiful and subtle oils, one that she herself particularly valued; it is also one of the most mysterious and intriguing. While it has generally been seen as a vertical, it can also be viewed in a horizontal orientation (fig. 35) and at times has been exhibited that way. Either direction works well, echoing an old sentiment that if the work is good it can be viewed in any way. This was in keeping with the drive to abstraction in early modernist art, reflecting the goal to make a painting as pure and abstract as a musical composition, an idea found throughout O'Keeffe's art, in paintings such as the two versions of *Music—Pink and Blue* (private collection, Saint Louis; Whitney Museum of American Art, New York). O'Keeffe's interest in the connection between musical composition and abstract painting comes as no surprise since her exposure in 1912 to Arthur Wesley Dow's teachings on art and music, via Alon Bement, had been instrumental in launching her as a serious painter. The approach was also common to the art of her dear friend Arthur Dove and informed paintings by others, including Morgan Russell, Stanton Macdonald-Wright, Andrew Dasburg, and James Daugherty, significant modernists also represented in the Kunin collection.[1]

Nor was a double orientation unusual in O'Keeffe's art, for certain paintings were exhibited or reproduced during her lifetime in both a horizontal and a vertical orientation. Sometimes the subject evolved into another image in the course of working on a painting, thus changing the orientation, or new images and meanings emerged after the work was finished. *Lake George Reflection* (c. 1921, private collection) started as a horizontal drawing, but the painting was shown in 1923 at the Anderson Gallery, her first major exhibition of oils, as a vertical.[2] Of a 1926 painting in the Shell and Shingle series, number *VII* (Museum of Fine Arts, Boston), O'Keeffe later wrote: "After painting the shell and shingle many times, I did a misty landscape of the mountain across the lake, and the mountain became the shape of the shingle."[3] This too refers to Lake George, as does the 1931 *Green-Grey Abstraction* when viewed as a horizontal, with what can be read as a sandbar at the right center. When viewed this way, the painting is no longer abstract, but a recognizable image of Lake George (see also *Lake George*; fig. 36), where O'Keeffe had spent so much time with Alfred Stieglitz, its dark water softened by the radiant, multicolored waves of the early morning light rising over the shore. In fact, when the painting is viewed as a horizontal, either side can be seen as top or bottom, making this an even purer composition.

Notes

1. See William C. Agee, *Synchromism and Color Principles in American Painting, 1910–1930* (New York: M. Knoedler and Co., 1965), for a fuller discussion of these ideas.
2. See Barbara Buhler Lynes, *Georgia O'Keeffe: Catalogue Raisonné* (New Haven: Yale University Press; Washington, D.C.: National Gallery of Art; Abiquiu, N.M.: Georgia O'Keeffe Foundation, 1999), vol. 1, 212, no. 394, For reasons not known, the painting is not reproduced in the catalogue proper but can be seen in two installation shots of the Anderson Gallery exhibition, 1923, in vol. 2, 1112, fig. 14, and 1113, fig. 17, where it is seen as a vertical and is recorded on 1102, no. 29. I am grateful to Doris Bry, long a preeminent authority on O'Keeffe, for bringing these sources to my attention and for her other insights into the artist.
3. Georgia O'Keeffe, *Georgia O'Keeffe* (New York: Viking Press, 1976), pl. 52.

Fig. 34
Georgia O'Keeffe
Green-Grey Abstraction, 1931
Cat. no. 49

Georgia O'Keeffe
Green-Grey Abstraction, 1931

Seen as a vertical, the painting appears virtually abstract, its possible sources or references eluding us. O'Keeffe herself gave us a clue, however, in a caption for *Green-Grey Abstraction* written in 1976: "There are people who have made me see shapes—and others I thought of a great deal, even people I have loved, who make me see nothing. I have painted portraits that to me are almost photographic. I remember hesitating to show the paintings, they looked so real to me. But they have passed into the world as abstractions—no one seeing what they are."[4] A portrait? Of whom? And how? Even if we do not know, we may relate the painting to the modernist practice of the symbolic or object portrait—developed by Francis Picabia, Marsden Hartley, and Charles Demuth—or to the then-current Surrealist devices of double, hidden imagery. This was not the first time O'Keeffe embedded a hidden portrait. About her 1930 painting *Black and White* (Whitney Museum of American Art, New York), apparently an abstracting reference to sky and cosmos, she wrote: "This was a message to a friend—if he saw it he didn't know it was to him and wouldn't have known what it said. And neither did I."[5] The use of rich, dark coloration surely connects the two paintings, but other references may always escape us, a continuing puzzle from an artist whom we thought we knew so well.

William C. Agee

4. Ibid., pl. 55.
5. Ibid., pl. 53.

Fig. 35
Georgia O'Keeffe
Green-Grey Abstraction, 1931
(horizontal orientation)
Cat. no. 49

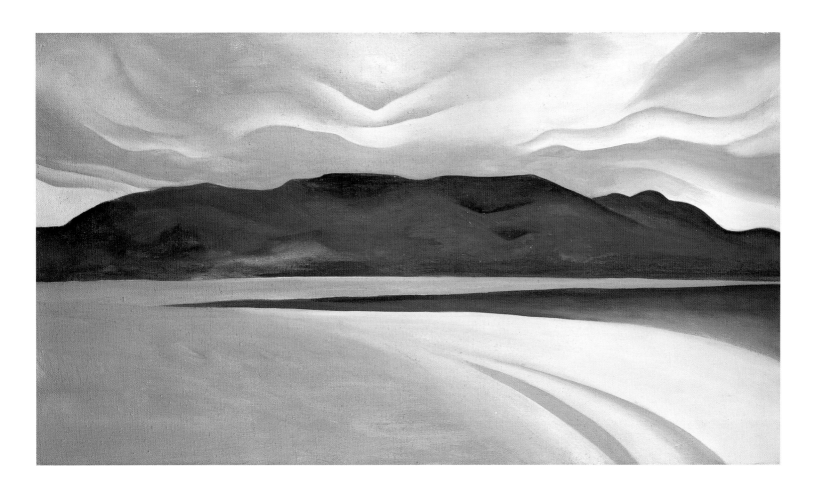

Fig. 36
Georgia O'Keeffe
Lake George, 1923
Oil on canvas
18 x 32 1/4 in. (45.7 x 81.9 cm)
Collection of Curtis Galleries, Inc., founder
Myron Kunin

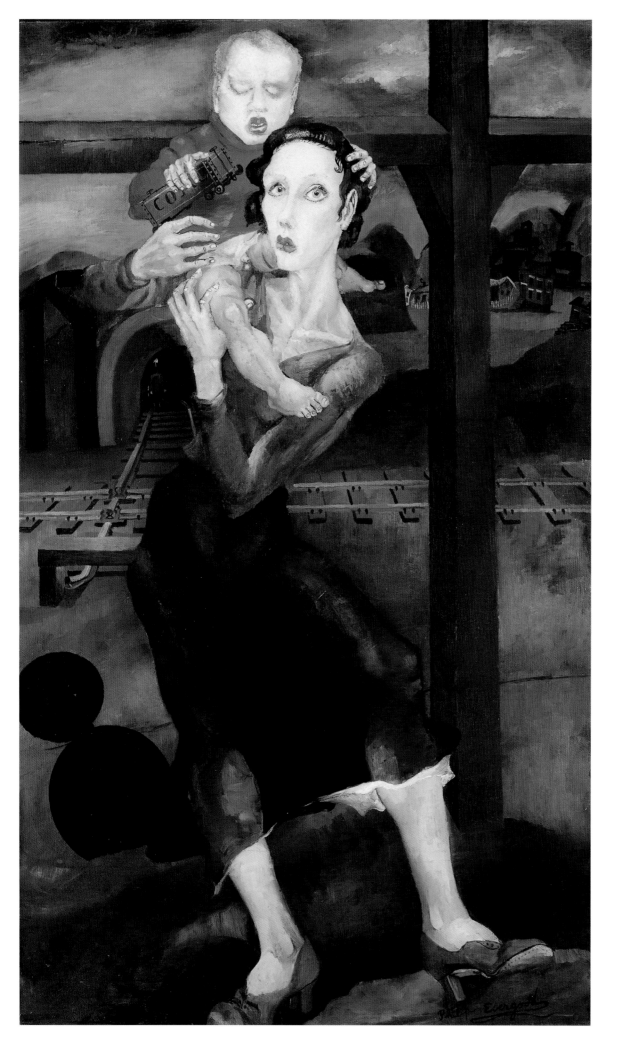

Philip Evergood
Madonna of the Mines, 1932

Notes
1. Grace Glueck, "Critic's Notebook:
On a Treasure Hunt for Art Stashed
among the Books," *New York Times*,
April 29, 2005.

Philip Evergood was probably the most slyly sophisticated artist working in America during the mid-twentieth century, hiding his technique behind what might seem like primitive tools. Everything about his work—the seemingly clumsy, almost reckless abandon with which he applied paint to canvas, often in a smeary and apparently directionless manner; the implied melodrama of exaggerated motion; the crabbed, scratchy wobble of the lines with which he delineated faces, hands, and limbs; together with the unabashed sentimentality of much of his subject matter— at first glance shouts "outsider artist." But the closer you look the more impressive his control over his method reveals itself to be. There is much more at work here than the "pure W.P.A. corn" critics such as Grace Glueck of the *New York Times*,[1] still terminally prejudiced by their 1950s training in "emotional neutrality," continue to register when they look at the art of the American Social Expressionists of the 1930s and 1940s.

Evergood's canvases, for instance, almost always exhibit a brilliant sense of compositional equilibrium. His *Nude with Violin* of 1957 (fig. 39) is a case in point. The woman he portrays sits on the super-firm horizontals of what would otherwise seem to be a rather rickety hospital-style bed. As her nude body mysteriously echoes the yellow lozenge pattern on the curtain that has slipped down into the painting's left-hand corner, away from the window it was supposed to cover, she herself gains monumental presence from the manner in which she leans, slightly off-balance, into the absolute verticality of the dark wall that perfectly outlines her chubby facial profile. Bedposts and buildings outside the window surge upward in consort with that wall, while wooden floorboards, the lines of the bed, and even the empty coat hangers behind the violinist create a balance that is in turn anchored by the slight diagonal formed by the instrument and its bow, which are strategically positioned above her loins. What is more, the woman's slightly unbalanced body is solidly anchored by the cloggy, bright red and yellow sandals that help weigh down her formidable feet. And then there are those spidery hands—an odd organic crawl of fingers demonstrating that this woman knows exactly how to play her instrument, whatever it might be. Gradually we begin to realize that *Nude with Violin* is an amazing composition that uses texture, light, color, and line in a sophisticated fashion to speak to some of the most visceral emotions within us.

Fig. 37
Philip Evergood
Madonna of the Mines, 1932
Cat. no. 25

Philip Evergood
Madonna of the Mines, 1932

Something similar happens in *Madonna of the Mines.* Evergood locks his subject—a miner's wife carrying her child on her shoulder—once again into a superbly composed space. In this case the mother's figure is balanced by the strong verticals and horizontals of a set of structural beams, which at the same time come to serve as a cross (which, in turn, is echoed in reverse by the rails leading out of the threatening coal tunnel behind the mother's waist). The child—almost preternaturally mature, his sex clearly identified to announce to the viewer his inevitable and unenviable fate as a miner-to-be, but as yet still unaware of that future—carries a toy coal train carriage, while his mother waits for her man to return from the dangerous mine. The look of anxiety on her face indicates that she fears the worst. Evergood strews about clues to the woman's tense emotional condition—the darkness of the scene, the deep blues and purples, the rickety row of houses in the distance, the stripped set of wheels without a carriage. As Lucy Lippard has pointed out, Evergood was never "satisfied to record only what he saw, he . . . recorded what and how he felt as well; his object was to remedy, to make more people see, through his art, what surrounded them."[2]

For those of us not laboring under dangerous conditions, Evergood is telling us here, it is all too easy to forget how cruelly we exploit the lives and families of those who do. Just around the time Evergood painted this work, his close friend and fellow social expressionist Harry Sternberg, who had spent considerable time among the Pennsylvania coal miners, described exactly what Evergood was trying to express here, as he tried to explain the motivation for his own delineations of the miner's life: "For this work, which next to steel making is occupationally the most dangerous, wages are paid that force the men to a living standard that is a shameful thing. Somehow all of this had to be expressed in my pictures. To have rendered only the surface drama and beauty of design and color would have invalidated all the months of living and working in coal, and I might have better remained in my studio and done 'pure' abstractions."[3]

In her novel *Yonnondio,* Tillie Olsen also tried to capture in words the emotions Evergood imbedded in his canvas: "Blood clot of the dying sunset and the hush. No sobs, no word spoken. Sorrow is tongueless. Apprehension tore it out long ago. No sound, only the

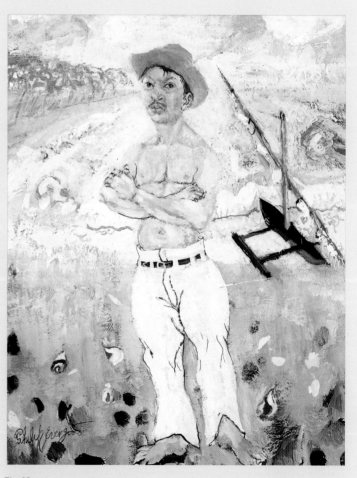

Fig. 38
Philip Evergood
Self-Portrait, 1957
Cat. no. 27

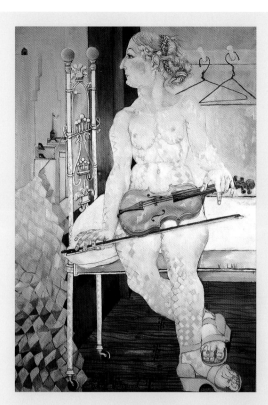

Fig. 39
Philip Evergood
Nude with Violin, 1957
Cat. no. 26

2. Lucy Lippard, *The Graphic Work of Philip Evergood: Selected Drawings and Complete Prints* (New York: Crown, 1966), 24.
3. Harry Sternberg, "Coal Town," in *No Sun without Shadow: The Art of Harry Sternberg* (Escondido: California Center for the Arts, 2000), 53.
4. Tillie Olsen, *Yonnondio: From the Thirties* (1934/1974; New York: Delta Books, 1989), 21.
5. "Statement by Philip Evergood," in *Twenty Years: Evergood* (New York: ACA Gallery, 1946), 27.
6. Ibid.

whimpering of children, blending so beautifully with the far cry of blown birds. And in the smothered light, carved hard, distinct, against the tipple, they all wait."[4] In the work of the American Social Expressionists of the 1930s and 1940s, there was none of that facile—and convenient—assumption that "real" art thrives on irony and intellectual distance that plagues so much contemporary art criticism—and, consequently, also much of our art. Evergood understood the importance of humane concern: "I feel the search of an artist should be for the richest and fullest of human experiences and that he should look for both the visual manifestations and those transmitted intuitively. The more the artist contacts the inner qualities of people the more he will understand Life and where he fits into it. The more mature he gets in his relationships to other human beings the more vital will be what he says in paint or stone."[5]

If we persist in considering sentiments of that sort "pure W.P.A. corn," we need to start worrying about the state of our hearts, for as Evergood also said: "What an artist puts into his work comes back to him."[6]

Bram Dijkstra

John Steuart Curry
The Flying Codonas, 1933

Alfredo Codona was the most famous circus performer of his age, celebrated for making the first "triple" in the history of modern aerial acts. People who saw the triple remembered it for the rest of their lives: Alfredo, a human cannonball rocketing across space in a series of three lightning somersaults toward his brother Lalo, who, dangling by his knees from the trapeze, upside down, waited for him with the solemnity of God the Father on the Sistine ceiling, reaching out to save the clay of mortal man.[1]

For those who witnessed it, the triple stayed in memory, frozen in time and space. The heat of the spotlights. The incessant rhythms of the circus band. The dizzying perspective view up, up into the snowy top of the circus tent. The ominous sway of the swings, as each brother calculates the moment when he is high enough, close enough, brave enough to fly off into the void, fifty feet above the sawdust. Actor Burt Lancaster saw Alfredo Codona's triple in Madison Square Garden as a young man. And he never forgot the terrible, glorious thrill of it. When he made *Trapeze* in 1956, it was as a tribute to that one dazzling act of bravado.[2]

When he ran off to join the circus—the Ringling Circus—for its spring tour through New England in 1932, John Steuart Curry was almost as famous as Alfredo Codona. A Kansas native, Curry was a painter of pictures, especially pictures of midwestern life in the Depression years. After his *Baptism in Kansas* (1928) was purchased by the fledgling Whitney Museum of American Art in 1931, he gained national stature as a Regionalist, a member of a movement whose works depicted, for the most part, the rural scene in hard times. Yet from the beginning, there was more to Curry than pigs and chickens (which he painted winsomely). *Baptism in Kansas* is a deeply symbolic statement about the relationship between American religious practice on the prairie and the iconography of great religious art. The dove (pigeon?) of the Holy Spirit hovers over the water trough. The preacher could be Michelangelo's Creator disguised in a rusty black frock coat.

So, too, with the Codonas, leaping into nothingness. Curry's reasons for joining the circus that year are unclear.[3] His first wife had just died. Money was tight. Perhaps he believed that the popular big-name acts he depicted—Clyde Beatty, the lion-tamer; Baby Ruth, the fat lady; the Wallendas on the high wire; the beautiful Reiffenach Sisters, riding bareback—would sell his paintings. But what he found was the eternal

Notes
1. Louis Zara, "The Flying Codonas," *Esquire*, July 1937, 131.
2. Karal Ann Marling, "Clowns with Bad Attitudes: Popular Culture Goes to the Circus," in *Images from the World Between: The Circus in Twentieth-Century American Art*, ed. Donna Gustafson (Cambridge: MIT Press; New York: American Federation of Arts, 2001), 130.
3. "Kansan at the Circus," *Time*, April 10, 1933, 41–42.

Fig. 40
John Steuart Curry
The Flying Codonas, 1933
Cat. no. 14

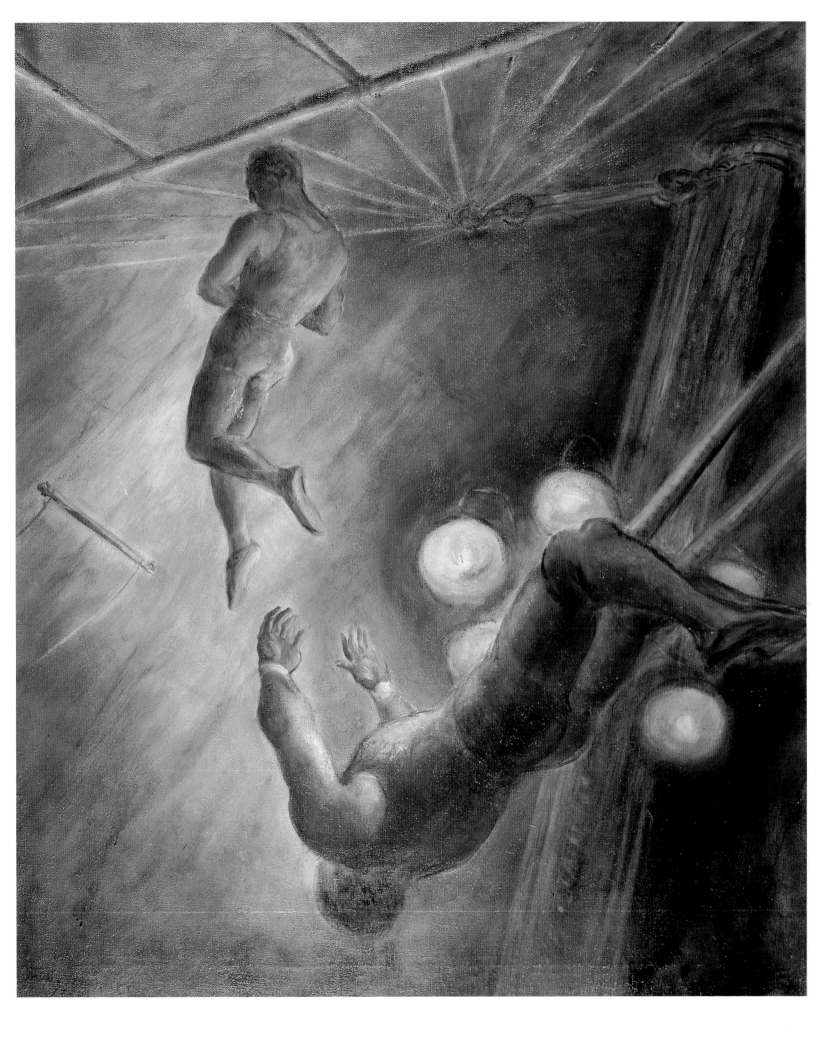

John Steuart Curry
The Flying Codonas, 1933

pathos of the human condition, on display in a spectacle that pitted the frail human body against the unforgiving forces of nature. The triple was an especially poignant illustration of the narrow distance between life and death.[4] It all came down to the ultimate risk, the sliver of emptiness between Alfredo's wrists and Lalo's fingers. As Alfredo told a reporter in 1930: "The history of the triple somersault is a history of death. . . . As long as there have been circuses, there have been men and women whose sole ambition was to accomplish three full turns in the air. . . . The triple somersault has killed more persons than all the other dangerous circus acts combined."[5]

Karal Ann Marling

4. See Patricia Junker, *John Steuart Curry: Inventing the Middle West* (New York: Hudson Hills Press, 1988), 157.
5. Alfredo Codona, "Split Seconds," *Saturday Evening Post,* December 6, 1930, 12–13.

Fig. 41
John Steuart Curry
Self-Portrait, 1935
Cat. no. 15

Reginald Marsh
Star Burlesque, 1933

For a brief but telling period of time, from the sassy "burlicue" queens in Thomas Hart Benton's murals for the New School for Social Research of 1930 to the aging stripper of Edward Hopper's 1941 *Girlie Show*, burlesque was an important subject for American painters. Clearly, the half-naked stars of the burlesque theater, in all their gaudy sexiness, embodied a dramatic revolt-in-progress against the Victorian prudery of the past. To be modern was to be explicit about matters of sex and sexuality. Marsh, who went to the movies almost as often as he turned up at Minsky's or the old Eighth Avenue Burlesque, saw Mae West in *I'm No Angel* only days before starting *Star Burlesque*.[1] The painted, marcelled, golden-haired goddess of his picture (a slightly tarnished bottle blonde), generous of proportion and utterly self-assured about her own powers of seduction, could be Mae West (or Jean Harlow) in the flesh, descended from the silver screen to mingle with the dubious gentlemen ranged along the runway.

Her costume is another sign of her shamelessness: a skirt of sorts, beginning at the knees, and sleeves, all puffed and pleated, like a bridal gown or the dress of a princess. But here the fabric frames the torso, nude except for the briefest of spangled G-strings. The costume, in its calculated nullity, turns what might otherwise have been a nude into a naked woman. The distinction is precisely what Marsh relished in this work and in his scenes of bathers at Coney Island or starlets arrayed in daring poses on New York movie marquees. These are pointed commentaries on American mores of the 1930s, in which the difference between the ethos of popular culture and the conventions of the studio—of "polite" society—often amounts to a well-placed pouf of tulle.

The joyless and sinister figures in the audience watch the star, and Marsh (and the viewer) watches her, in much the same way that the painter attends to his model in the studio. Marsh compares one act of viewing with another in *Star Burlesque*. In the studio, the nature of the transaction between observer and observed is denatured by tacit agreement. Art is bloodless, exalted. Or is it? Within the smoky confines of the old theater, with its gilded balconies, nakedness—nudity—is a show, an invitation, a lonely, furtive sexual release. In Benton's autobiography, he remembered nights in just such a place, before he was respectably married: "I . . . think of the burlesque shows, particularly of the one on 14th Street, now gone . . . where the art of 'stripping' just began, [and] used to make the old boys drool at the mouth and keep their hands in their pockets."[2]

Notes
1. Marilyn Cohen, *Reginald Marsh's New York* (New York: Dover, 1983), 12–13.
2. Thomas Hart Benton, *An Artist in America* (New York: Robert N. McBride & Co., 1937), 269. See also "Tom Benton's 'Girls' as Reverberations of Modernization," in James M. Dennis, *Renegade Regionalists: The Modern Independence of Grant Wood, Thomas Hart Benton, and John Steuart Curry* (Madison: University of Wisconsin Press, 1998), 121–25.

In the background, at the left edge of the composition, the chorus line seconds the movements of the star, each one dressed as a clown, in a ruff, a funny hat, and not much else. Like clowns, in the end, these entertainers are hidden and transformed by their costumes. Their near-nakedness becomes a kind of invisible garment, a cloak of indifference to the gaze of the audience and their seedy surroundings. Somehow, the bits of cloth make the "star" and her entourage inviolate as vestals, indifferent to and untouched by the hurly-burly of modern New York.

Karal Ann Marling

Fig. 43
Reginald Marsh
Star Burlesque, 1933
Cat. no. 43

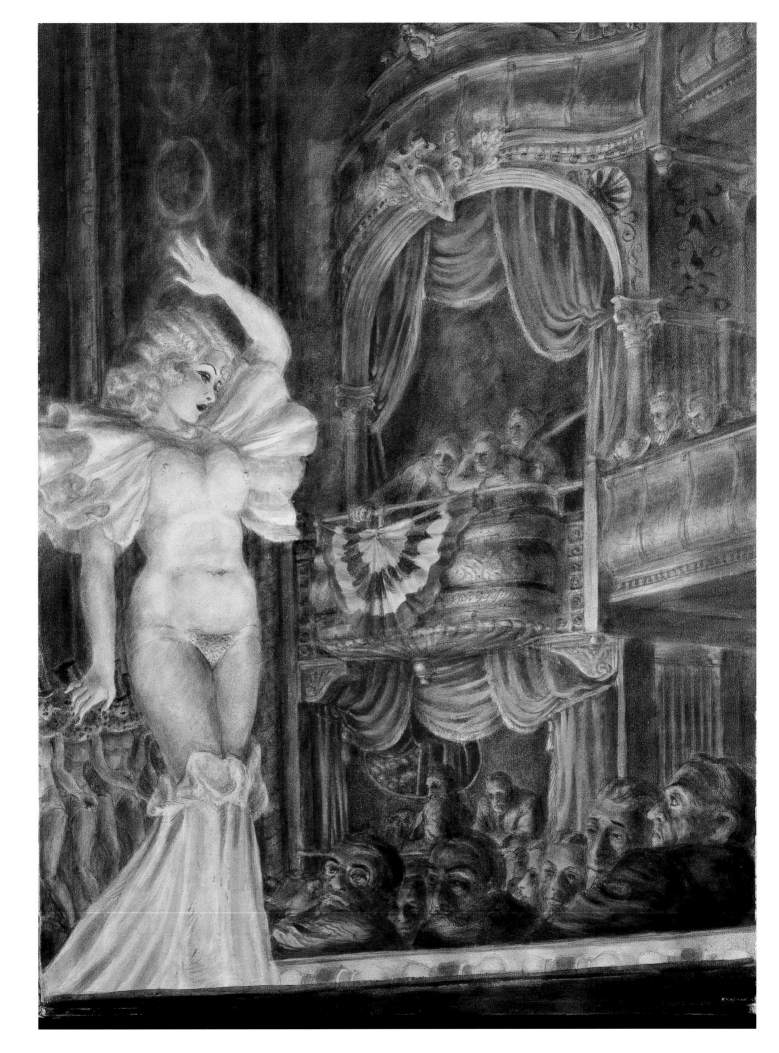

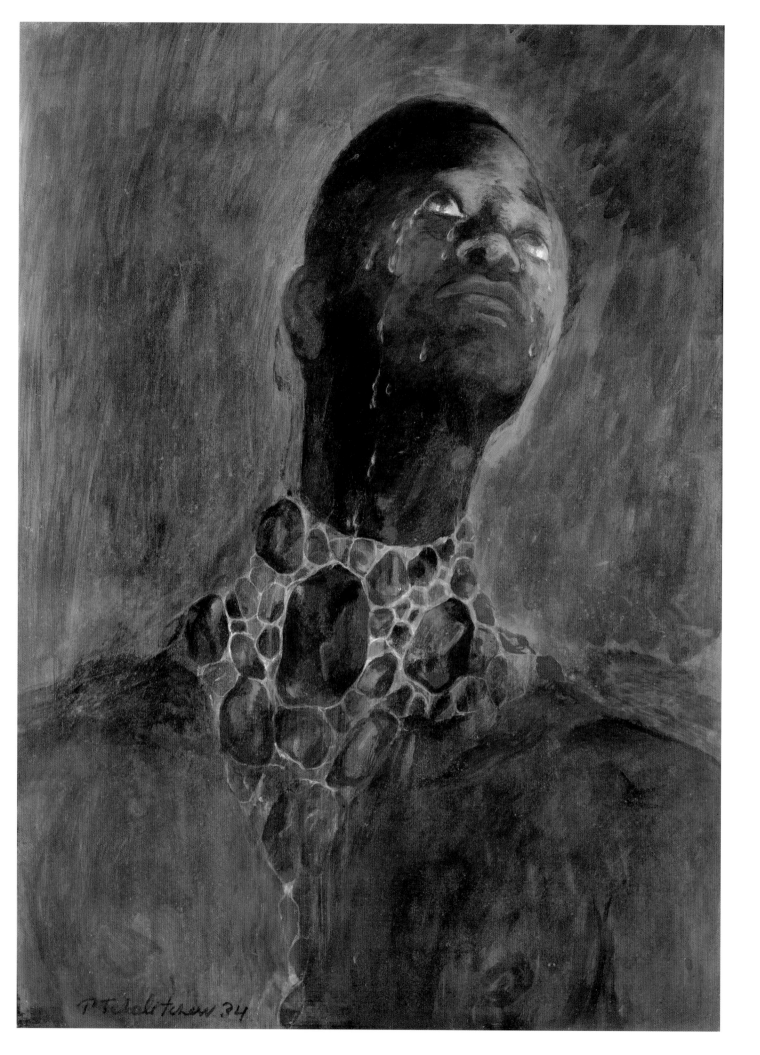

Pavel Tchelitchew
Weeping Negro, 1933

Notes

1. Edouard Roditi, *Dialogues on Art* (Santa Barbara, Calif.: Ross-Erikson, 1980), 114.
2. Parker Tyler, *The Divine Comedy of Pavel Tchelitchew* (New York: Fleet Publishing, 1967), 382.
3. Margaret Rose Vendryes, "Casting *Feral Benga:* A Biography of Richmond Barthé's Signature Work," *Masters of African American Art*, June 2003, Anyone Can Fly Foundation, http://www.anyonecanflyfoundation. org/library/Vendryes_on_Barthe_ essay.html.

Born into an aristocratic Russian family, Pavel Tchelitchew moved with his parents to Kiev in 1918, after their estate near Moscow was seized at the outbreak of the Russian Revolution. By 1921 he was in Berlin, and in 1923 he settled in Paris, where, as an experimental stage designer of note, he created sets and costumes for the Ballets Russes. A complex allegorist and mystical thinker, Tchelitchew was influenced by such avant-garde art movements as Constructivism, Expressionism, Cubism, and Surrealism. He allied himself with the innovations in technique and spatial representation that they charted but adamantly rejected pure abstraction as a "denial of art."[1]

Preoccupied with the human face and figure for both their symbolic possibilities and their erotic expressiveness, Tchelitchew developed an elaborate symbolic vocabulary that encompassed alchemy and mythology, the orthodox and the occult. His visual temperament was rooted in a persuasive realism that eschewed both the clichés of fantasy and the lyricism of his Neoromantic contemporaries.

The circus, with its dark humor and tumbling acrobats, was a recurring subject for the artist in the early 1930s. Responding to Pablo Picasso's earlier circus paintings, Tchelitchew's studies of circus performers have a dramatic quality that contrasts with the serenity of Picasso's works. In the early 1930s Tchelitchew also painted a series of portraits of performers covered with banding tattoos, including *Acrobat in Red Vest* (fig. 45). These "pictures within pictures" illustrate the artist's interest in the layering of images. Such hieroglyphic overlays furthered his exploration into the possibilities of metamorphic imagery.

Also indicative of Tchelitchew's interest in striking images of performers is *Weeping Negro*. According to Parker Tyler, the painting is one of three portraits the artist made in 1933 of the celebrated Senegalese dancer François Benga, who starred at the Folies Bergère in Paris, using the stage name Feral Benga.[2] Benga was a professional chorus dancer who appeared with performers such as Josephine Baker, "who drove Parisian audiences wild with carnal choreography often set in steamy and distant places."[3] His exotic stage persona made him a popular subject for other artists and a fixture of bohemian circles. In *Weeping Negro*, Benga's head is thrown back in a classical pose suggesting both pain and ecstasy. Fragments of electric white and neon blue paint, woven throughout the composition, heighten the painting's charge. Cropped vertical lines accentuate the sharp pull of the sitter's neck. Encircling

Fig. 44
Pavel Tchelitchew
Weeping Negro, 1934
Cat. no. 70

Pavel Tchelitchew
Weeping Negro, 1933

Benga's neck is a "collar of viscous tears like rhinestones."[4] The wearer of this stupendous necklace is portrayed as weeping, and it is as if his tears have been transformed into a startling, luminescent ornament.

In 1934 Tchelitchew moved to New York with his companion, the poet and critic Charles Henri Ford, and he became an American citizen in 1952. Tchelitchew produced illustrations for *The Young and Evil* (1933), a pioneering novel on gay culture written by Ford and Parker Tyler, and later collaborated on the development of Ford's magazine *View,* a leading journal of avant-garde art and literature, which was published from 1940 to 1947. He also continued to design for the stage, working with the Metropolitan Opera and Balanchine's fledgling American Ballet. In a remarkable body of work made in the United States between 1934 and 1952, Tchelitchew continued to focus on figurative, highly allegorical imagery, while concerning himself thematically with the portrayal of human suffering in works such as *Phenomenon* (1938). One of his most acclaimed paintings from this period, *Hide and Seek* (1940–43), which hangs in New York's Museum of Modern Art, depicts an enormous, mysterious "tree of life," filled with anthropomorphic apparitions and delicately threaded forms.

Dana Simpson

4. Tyler, *Divine Comedy,* 382.

Fig. 45
Pavel Tchelitchew
Acrobat in Red Vest, c. 1930
Oil on board
41 1/2 x 29 3/4 in. (105.4 x 75.6 cm)
Collection of Curtis Galleries, Inc., founder
Myron Kunin

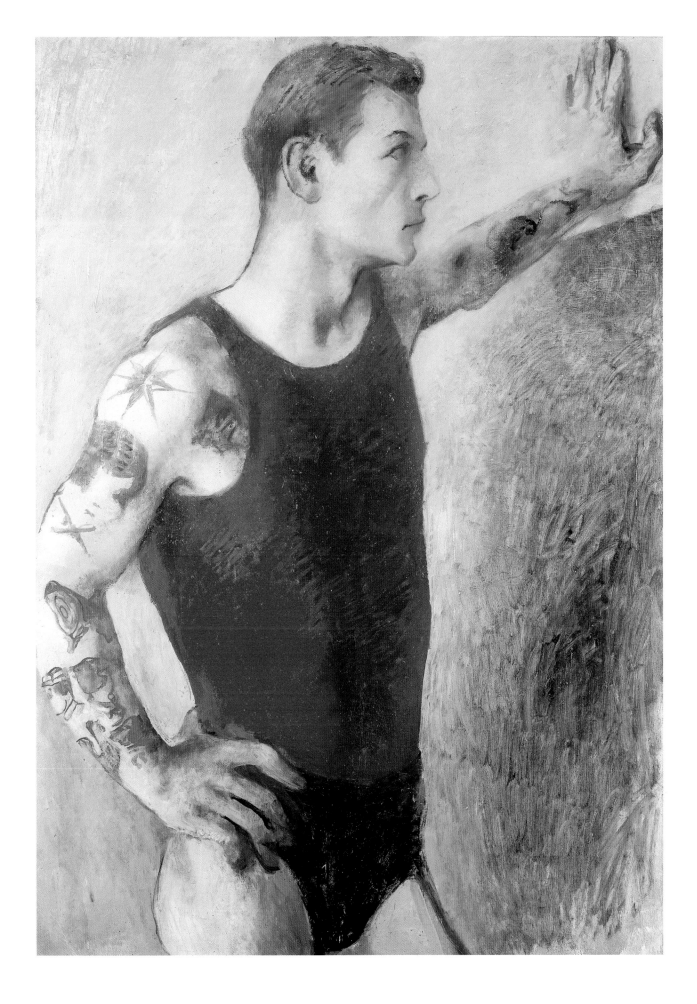

Grant Wood
Return from Bohemia, 1935

Notes
1. James Dennis comments on Wood's interest in dress and setting in his introduction to Wood's own "Revolt against the City," in Joseph S. Czestochowski, *John Steuart Curry and Grant Wood: A Portrait of Rural America* (Columbia: University of Missouri Press, 1981), 128.
2. Wood, in *New York Herald Tribune,* January 19, 1936. See Brady M. Roberts, "The European Roots of Regionalism: Grant Wood's Stylistic Synthesis," in Roberts et al., *Grant Wood: An American Master Revealed* ([Davenport, Iowa]: Davenport Museum of Art; San Francisco: Pomegranate Artbooks, 1995), 32.
3. Cited in Wanda Corn, *Grant Wood: The Regionalist Vision* (New Haven: Yale University Press, 1983), 112.

Grant Wood came from Iowa, left it infrequently, and as an enthusiastic member of the Regionalist triumvirate of the 1930s—Wood of Iowa, Thomas Hart Benton of Missouri, John Steuart Curry of Kansas—was proud of the fact. He wore farmer's bib overalls when he painted and, when Curry came to visit in 1932, persuaded his more cosmopolitan friend to pose for pictures in the same outfit. Dress, setting, habits—the folkways of the midwestern farmer—were basic to his desire to create an indigenous art of the heartland.[1] But dress was of particular importance. In his best-known work, *American Gothic* (1930), the viewer grasps the identity of the farmer and his wife because of their costumes. Rickrack and denim make for proper Iowans, along with the "Carpenter Gothic"–style farmhouse behind them.

Return from Bohemia is an illustration intended as the dust jacket for a book of the same name (never finished). Wood signed a contract in 1935, and in January of the following year, the drawing appeared in a Sunday edition of the *New York Herald Tribune,* along with a syndicated story accounting for the image in terms of a deliberate change in the artist's personal appearance between his brief stay among the bohemians of Paris in the 1920s and his new, reformed self. It all came down to a goatee (and big owl's-eye horn-rim glasses). "I lived in Paris a couple of years," he said, "and grew a very spectacular beard that didn't match my face . . . and was convinced that the Middle West was inhibited and barren." His fellow bohemians mainly sat around the Café du Dôme, nursing their muses with brandy. "It was then I decided that all the really good ideas I'd ever had came to me while I was milking a cow. So I went back to Iowa."[2]

Hail the Prodigal Son, back from Paris, ensconced in front of a good red Iowa barn, presumably painting good, solid Iowa folk, with those subjects looking on while he does so. A farm woman in polka dots, with rickrack trim. A kid in overalls and a denim cap. A little girl in tablecloth checks. An older fellow in a cloth cap and a chambray work shirt. Wood himself, oddly enough, is not wearing his overalls, perhaps to indicate that he is not *really* a farmer himself—just an Iowa boy in a much-washed shirt, solemnly inspecting a canvas, which we cannot see. Is the hidden picture full of Iowans?

Perhaps so. Periodically Grant Wood seems to have wondered if coming home had been a good idea. A local chapter of the Daughters of the American Revolution had given him grief over a 1927 commission to create a stained-glass window in memory of Iowa's war dead. The only firm he could find capable of fabricating the window was in Munich, Germany. The ladies excoriated him for consorting with the enemy. He once told a Cedar Rapids reporter that if he were going to paint a self-portrait, the background would be full of "loafing bystanders," their faces full of "contempt, scorn and an I-know-I-could-do-it-better look."[3]

The spectators in the barnyard of *Return from Bohemia* do not seem particularly scornful, but they are indifferent to the artist, who works away with an almost frightening intensity. Perhaps, as his subjects, they are meant to behave nicely in their rickrack and checks. They are mere symbols, dressmaker's dummies, inert until the hand of the painter turns them into meaningful, enchanted Iowans.

Karal Ann Marling

Fig. 46
Grant Wood
Return from Bohemia, 1935
Cat. no. 75

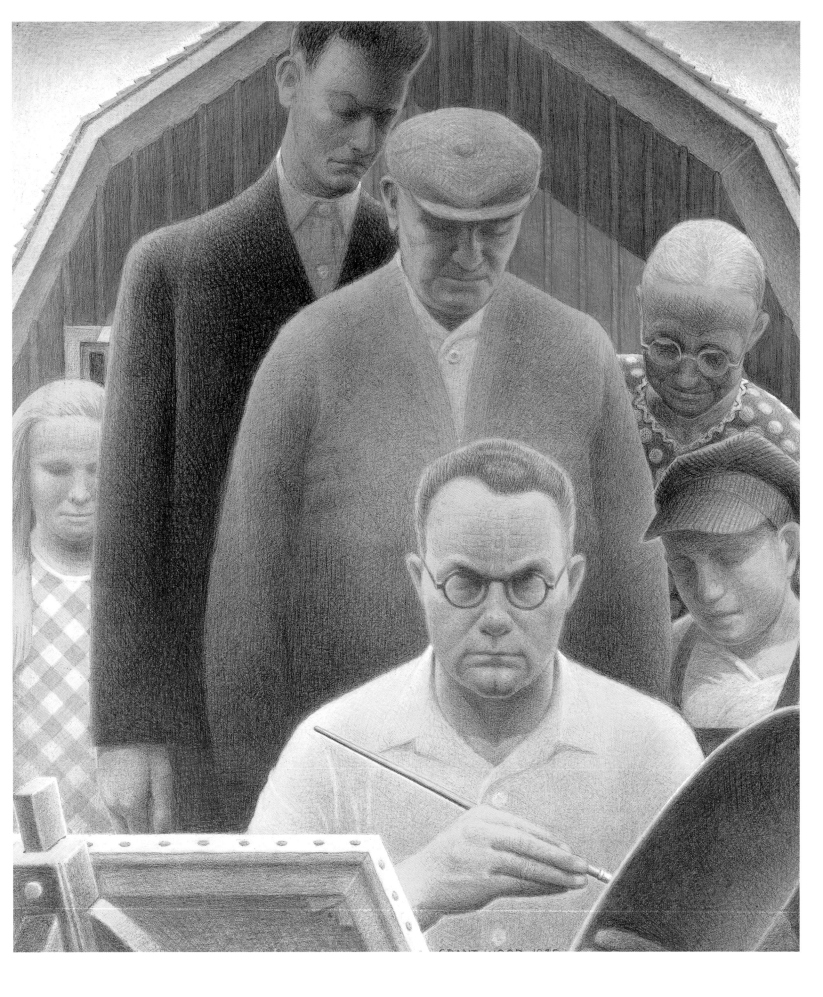

Paul Cadmus
Aspects of Suburban Life: Main Street, 1937

In 1936 Paul Cadmus was commissioned by the Treasury Relief Art Project (TRAP) to paint a series of four murals to decorate the lobby of the U.S. Post Office in Port Washington, New York, an affluent Long Island commuter suburb of Manhattan. TRAP was an early New Deal program—a kind of pilot project—aimed at providing relief payments for artists during hard times while bringing art of quality to the public in the places where people lived and worked.

That Cadmus had been selected for a big job was something of a miracle. In 1934 he had been at the center of a scandal when a picture painted for an earlier program had been barred from an exhibition at the Corcoran Gallery of Art in Washington, D.C., on the grounds of objectionable content. Called *The Fleet's In!* Cadmus's work depicted sailors on shore leave importuning local ladies as a censorious older woman turns away in disgust. According to *Time* magazine, the secretary of the navy condemned the picture as a blatant insult to the navy. It represented, that irate gentleman said, "a most disgraceful, disreputable drunken brawl, wherein apparently a number of enlisted men are consorting with a party of street-walkers."[1] Overnight, Cadmus became the enfant terrible of American art.

In the *Main Street* panel of the Port Washington murals, he did it again. Old ladies recoiling in horror at the sight of nubile young women and country-club matrons in tennis shorts passing by. Local yokels lounging outside the local drugstore (flavor of the day? chocolate), casting lascivious glances at the girls. Dogs. Traffic cops. Disorder. A car broken down in the middle of the street; tools everywhere. Chaos. Scholars have rightly noted that Port Washington was the kind of place F. Scott Fitzgerald had described in *The Great Gatsby*, a decade earlier—essentially careless, frivolous, bent on pleasure.[2] The messy contents of Main Street suggest that this is indeed Fitzgerald's "West Egg," or a town just like it (as do the artist's other subjects: polo, golf, the town dock). And that, in the end, is what made the Cadmus murals so objectionable that *Main Street* was shipped back to the artist as soon as it was received, while the other panels were buried away for many years in the billiard room of the American embassy in Ottawa.

The Great Depression did not call for leering loafers, tennis players, and wild disorder—at least not in government-sponsored murals.[3] The ideal was earnestness. Hard work. History. Tidiness. Restraint. Or everything Cadmus's rollicking, sharp-edged satire was not. In addition, there was the matter of style. Cadmus used an old master surface of oil and tempera on wood panel and an old master approach to anatomy and perspective that lent his pictures a perverse dignity, even when the people depicted seemed to exude a lubricious indifference to the human condition outside their suburban playground. The themes were a challenge to the stolid, deeply engaged subject matter of Social Realism. But so was the surface, the dazzling color, the quivering flesh—even the yappy little lapdog, straining at its leash.

Karal Ann Marling

Notes
1. *Time*, April 30, 1934, quoted in Lincoln Kirstein, *Paul Cadmus* (New York: Imago, 1984), 25.
2. Elizabeth N. Armstrong, "American Scene as Satire: The Art of Paul Cadmus in the 1930s," *Arts Magazine* 56 (March 1982): 122–23.
3. Karal Ann Marling, *Wall to Wall America: Post Office Murals in the Great Depression* (Minneapolis: University of Minnesota Press, 2000), 282–89, and "New Deal Iconography: Futurology and the Historical Myth," *Prospects* 4 (1979): 421–40.

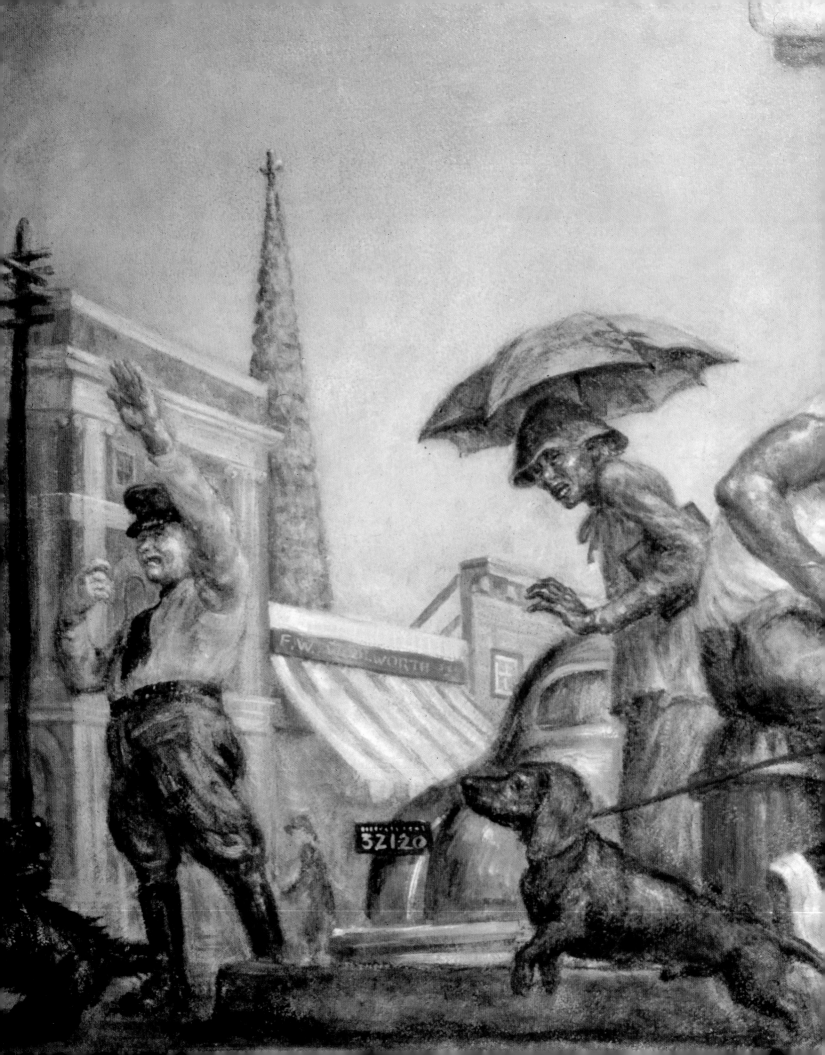

Ben Shahn
Self-Portrait among Churchgoers, 1939

The church: Our Lady of the Angels, Webb Avenue, the Bronx. The week's sermon, according to the emphatic signboard on the lawn: "Is the Government Fostering Irreligion in Art?????" But the artist, a Lithuanian-born Jew, is no churchgoer. Shahn's chipper presence on the sidewalk among the somber churchgoers is an act of silent protest.

Whether or not he intended to be, Ben Shahn was one of the most influential photographers of the Depression era. A recognized painter of social causes, he reportedly bought a thirty-five-millimeter Leica at the suggestion of Walker Evans, with whom he shared a studio, intending to use the little camera as a kind of note-taking device. Shortly thereafter, both Evans and Shahn became mainstays of the government's effort to document hard times in photographs in order to sell New Deal relief programs to the nation and its legislators. On a series of research trips for the Farm Security Administration (FSA), Shahn photographed American workers at their labors. These photographs would become a basis for a major cycle of mural paintings in the Bronx Central Post Office in 1938–39.

The documentary impulse—the notion of an unmediated, uncorrected view of reality—was the major aesthetic preoccupation of the 1930s.[1] Franklin Roosevelt spoke to the nation by radio in apparently spontaneous "Fireside Chats" that reached directly into America's homes. In contrast to the cropped and manipulated rotogravures of the 1920s, the black-and-white images presented by magazines such as *Life* (1936) and *Look* (1937) seemed raw and real.[2] Polished texts were suspect: words could lie. But pictures carried with them a built-in guarantee of truth. Cameras, after all, were mechanical eyes without bias or opinion. Point and shoot. There it was.

Even as the FSA pictures were being taken, however, critics began to point out that photographs could easily be made to lie too. During the famous "cow skull" scandal of 1936, political enemies of the White House revealed that Arthur Rothstein had moved a prop to make his picture a more poignant emblem of the Dust Bowl—and more useful as propaganda.[3] Walker Evans routinely rearranged his subjects and their settings. Ben Shahn loved the right-angle viewfinder, a variation on the old spy camera, which allowed the photographer to face away from his subjects—to become part of an anonymous group of churchgoers in proper Sunday-morning dress—in order to catch life unawares.

Notes
1. William Stott, *Documentary Expression and Thirties America* (New York: Oxford University Press, 1973), 67–91.
2. Tom Hopkinson, "Scoop, Scandal, and Strife: A Study of Photography in Newspapers" (1971), in *Photography in Print: Writings from 1816 to the Present*, ed. Vicki Goldberg (New York: Touchstone, 1981), 299.
3. James Curtis, *Mind's Eye, Mind's Truth: FSA Photography Reconsidered* (Philadelphia: Temple University Press, 1989), 75–76.

Fig. 49
Ben Shahn
Self-Portrait among Churchgoers, 1939
Cat. no. 60

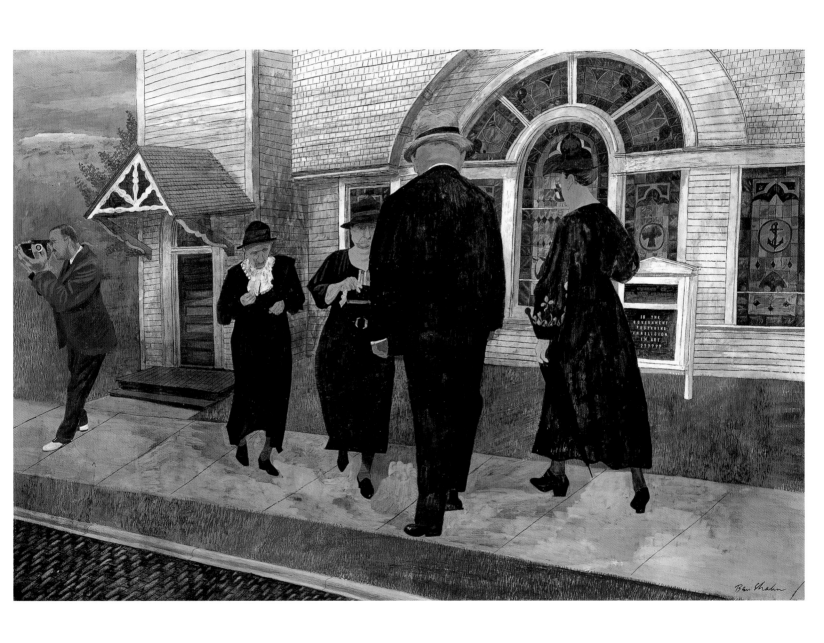

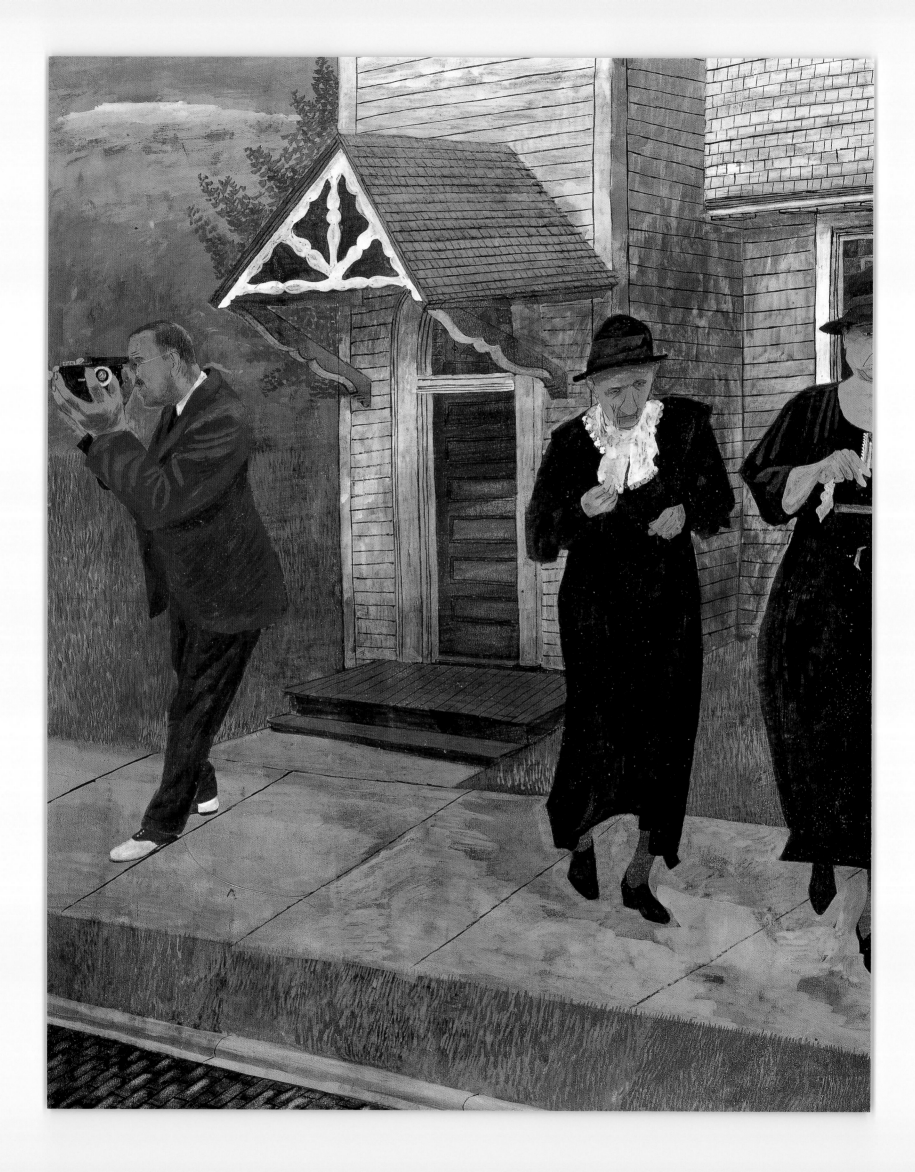

Ben Shahn
Self-Portrait among Churchgoers, 1939

4. "Catholic Educator Denounces Whitman Lines in Mural," *Washington Star*, December 12, 1938.

And so he lurks here, outside Our Lady of the Angels, taking pictures on the sly. But his presence is no real secret. He's the one in the casual clothes. His sporty saddle shoes are the brightest spots of light in the picture. And he's angry. On one of his thirteen panels in the Bronx Central Post Office, he had inscribed phrases from a poem on the dignity of labor by New York's Walt Whitman. As he was finishing his work, a Catholic priest from nearby Fordham University on Rose Hill happened into the building. Because Whitman's poetry was then listed on the index of works condemned by the Church, he launched a protest against Shahn's work to the Treasury Department, the commissioning agency. To their credit, federal art administrators backed Shahn and his beautiful murals but not before the Catholics of the Bronx came to suspect that the government was fostering godless impiety under their very noses.[4]

The stained-glass window at the right edge of the picture, opposite the photographer, is centered on an anchor, the Christian symbol of hope. Ever the optimist, Shahn hopes for the best, even as he paints the dark, self-enclosed clump of churchgoers as a mass of fear and suspicion, set off against his own colorful, active self, plying his trade in the neighborhood. The reporter, in the end, is the most important figure in the scene: the intruder, the watcher, the artist, determined to snatch the truth wherever he can find it.

Karal Ann Marling

Fig. 50
Ben Shahn
Self-Portrait among Churchgoers, 1939 (detail)
Cat. no. 60

Marsden Hartley
Madawaska—Acadian Light-Heavy, 1940

"I am utterly in the world of nature here, and it has saved my life—and my love for mountains never diminishes," Marsden Hartley wrote to Gertrude Stein in 1933, from Garmisch-Partenkirchen, in Bavaria. The "magnificent heaps of stone" with which he found himself surrounded there stirred his senses in very much the same way the rock-hard muscles of young men did.[1] That is why his portrait of the wrestler Madawaska treats the young man's chest and torso as if it were a mountainous heap of chiseled stone. That is also why, in such landscapes as his *Embittered Afternoon of November, Dogtown* (1931; fig. 52), the huge rocks Hartley loved to paint so often call to mind mottled skin, muscle, and bone—fragments of primordial humanity. And just as in the Dogtown paintings invariably a few embattled trunks of trees struggle through the hardened soil of a nature grown too cold and closed off from all sentimentality to tolerate the primacy of feeling, so Madawaska's neck emerges from his torso like the hardened trunk of a tree stubbornly breaking apart the otherwise virtually impermeable erotic neutrality of nature to seek the light of human interaction.

The light that flashes past the wrestler's shoulder, side, and arms suggests the living warmth of his body, reminding us that he is a mortal being, one of those "consummate men / each loving each, / each loving me, and then / showing these in a dream / of men," Hartley feared had, by this time of his life, departed from his world forever.[2] Hartley's poem had been inspired by the drowning of the two sons of Francis Mason, members of a Nova Scotia family that he had befriended, and a third boy, their cousin. "I fell in love with the most amazing family of men & women the like of which I have never in my life seen—veritable rocks of Gibraltar in appearance, the very salt of salt. . . . I was swept away by the tidal forces of their humanism," he wrote to Adelaide Kuntz.[3]

Their deaths were like the passing of an entire world to him. In the years that followed, Hartley tried to resurrect fragments of that world in the numerous paintings of muscular males he made during the last few years of his life—works among which his two portraits of Madawaska are stellar examples. Although the portrait under discussion here is generally designated as Hartley's "second arrangement" of the figure, there are many elements that would indicate that it was the artist's *first* attempt at capturing the Acadian wrestler's exquisite corporeality. There is in the wrestler's stance in this version an element of youthful hesitation—a diffidence that echoes through both the young man's soft and somewhat uncertain glance and in his rather hesitant

Notes
1. Marsden Hartley, *Somehow a Past: The Autobiography of Marsden Hartley,* ed. Susan Elizabeth Ryan (Cambridge: MIT Press, 1997), 162–63.
2. Marsden Hartley, "Three Loving Men," in *Marsden Hartley and Nova Scotia,* ed. Gerald Ferguson (Halifax: Mount Saint Vincent Art Gallery in association with the Press of the Nova Scotia College of Art and Design and the Art Gallery of Ontario, 1987), 129.
3. Quoted in Ferguson, ed., *Marsden Hartley and Nova Scotia,* 39.

Fig. 51
Marsden Hartley
Madawaska—Acadian Light-Heavy, 1940
Cat. no. 34

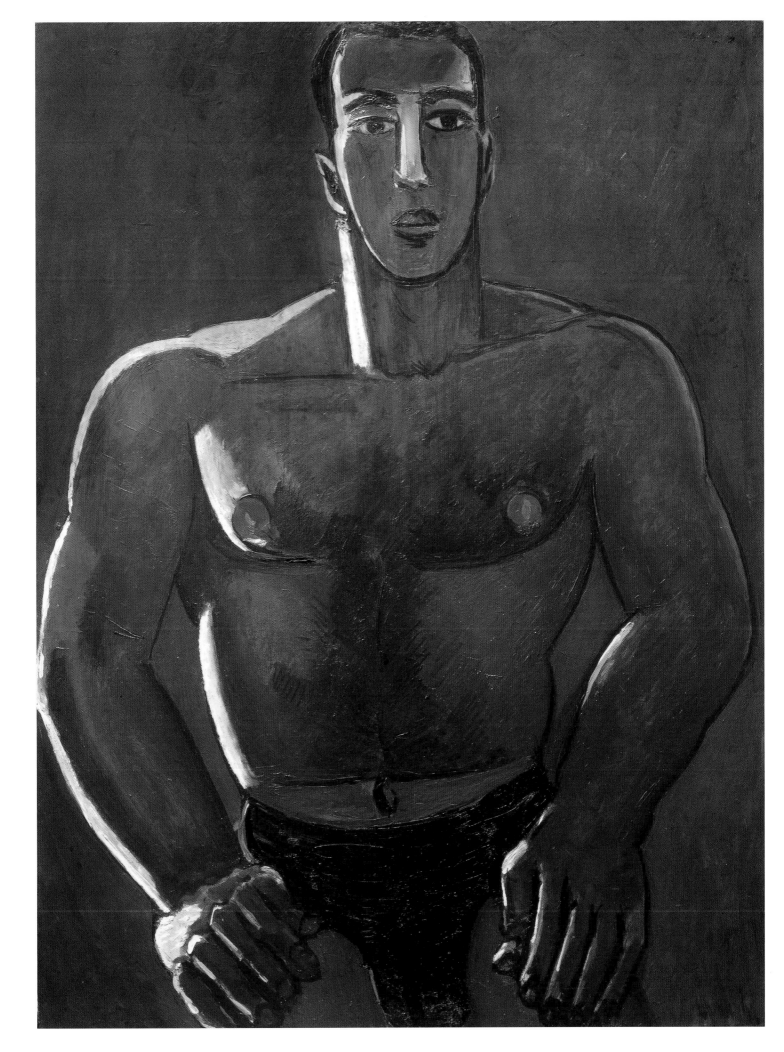

Marsden Hartley
Madawaska—Acadian Light-Heavy, 1940

pose, his body curving forward slightly as he places his formidable hands on his thighs. In the Art Institute of Chicago there is another version—a later one, it would seem—in which Hartley tried to correct these elements of indecision. In that version the Acadian is more powerful, more decisive: with his hands behind him now, his far more chiseled body becomes a "rock of Gibraltar" indeed, a dream of manhood in a sea of passionate red. Dressed in only a jockstrap, his face ringed by the stubble of a five o'clock shadow, his eyes inscrutably locked on the viewer, he looms over us in a fashion that is for Hartley uncharacteristically authoritarian, as if to separate himself from mere mortality.

Recently it has been suggested that "Hartley's late figural paintings share qualities with Nazi art and posters that propagated images of the masculine, muscular New Man." But this is a comparison that can be sustained only if we insist that a shared iconography ("idealized bodies, exaggerated musculature, thin waists, broad chests, and hard-edged angular features") also translates into "shared qualities" of mind.[4] But just because Nazi artists painted idealized mothers as often as American painters did, the iconography of tender motherhood does not necessarily make critics think of fascism. The imagery of muscular manhood can be just as variable in its range of affects, and hence its ideological implications.

When it comes to determining the effect of subject matter on the viewer, such things as emotional impact, style, and the intangibles we categorize as "feeling" count far more than iconography as such. A Nazi ideologue such as the sculptor Arno Breker may have used an iconography not unlike Hartley's, but the bodies of Breker's racially pure masculine warriors (and those of Nazi art in general) are emphatically superhuman in their preternaturally three-dimensional ideality. They make us equate masculine beauty with racial purity. Hartley's muscled males are no less ideological, but they present a very different idea of human beauty. The Nazis, driven by a spurious concept of humanity's imminent capacity to transcend the flawed workings of instinct, sought the answer to the world's problems in eugenics and a consequent triumph of the human will over what they regarded as brute nature.

In contrast, what is virtually always most striking about Hartley's adoring eyes caressing the male figure is that, in stark opposition

4. Donna M. Cassidy, *Marsden Hartley: Race, Region, and Nation* (Durham: University of New Hampshire; Hanover, N.H.: University Press of New England, 2005), 243–44.

Fig. 52
Marsden Hartley
The Embittered Afternoon of November, Dogtown, 1931
Cat. no. 33

to the hieratic world of male dominance posited by the Nazis, he sees—or dreams that he sees—the humane heart, that warm, embracing human nature that, he hoped, would be the basis of community. He always remains convinced that love huddles beneath the steely muscles of his ideal men. Their musculature is a blanket covering those "tidal forces of their humanism" that sweep Hartley willingly into the rough seas of primal nature. His paintings of muscular men celebrate a Whitmanesque world in which humans can still become one with every rock, with every wave, and with every blade of grass that, by its presence, continues to defy the arrogant superiority of a species of being that has paved over the soil that we must honor if we want things of beauty to grow in this world. In the year before his death, he painted *Prayer on Park Avenue* (fig. 53). The man kneeling on the cold concrete of the sidewalks of the well-to-do, brutally separated from the vestiges of greenery left to the city dweller by a spiked metal fence as threatening as a row of bayonets, is clearly a mental image of the artist himself as mendicant—a forlorn member of the fading humanist order of the sons of nature, praying to be delivered from the evils of a warring world.

In other words, Hartley was always first and foremost a true humanist. He saw the human body, the body of the other, as a harbor of warmth and human deliverance. It is a message of hope that he kneaded with trembling fingers into this first portrait of Madawaska. For the Nazis, in striking contrast, the male body was a steel trap of infallible authority, brutal imperialism, and harsh doctrinal force, its message an antihumanist ideology of arrogance and destruction.

Bram Dijkstra

Fig. 53
Marsden Hartley
Prayer on Park Avenue, 1942
Cat. no. 35

Charles Sheeler
Conversation—Sky and Earth, 1940

By the early 1940s, when Charles Sheeler executed *Conversation—Sky and Earth*, his career and reputation had undergone a major transformation on two levels. First, he had made a professional shift from photography to painting, and second, he had firmly established his identity as a modernist on the basis of highly successful works celebrating industry, such as his commissioned series of photographs of Ford Motor Company's River Rouge plant (1927), some of which later served as the foundation for paintings.

That Sheeler had secured his reputation as a painter by 1938 is evidenced by the second major industrial commission of his career, this time from *Fortune* magazine, for a series of paintings that would popularize and glorify the theme of "power." He crossed the United States in search of subject matter during 1939. Boulder Dam, a new feat of structural engineering on the Nevada-Arizona border, was the last destination in his peregrination.[1] Using a nine-by-twelve-centimeter drop-bed folding camera,[2] Sheeler documented the dam from many vantage points, including expansive elevated views of the reservoir above and the channel gorge below set within the context of the greater landscape. The monumentality, immensity, and sublimity that he sought in his subject were located in the void of the gorge, however, far below the towering wall of the dam. Looking up, he framed the central image (*Boulder Dam, Transmission Towers*, gelatin silver print) on which he based *Conversation—Sky and Earth* the following year. This painting, along with the others from the Power Series, was reproduced in the December 1940 issue of *Fortune*, while the actual canvases were on display at Edith Halpert's Downtown Gallery.

Perspective, high-contrast palette, crisp rendering and cropping, and the absence of any allusion to movement impart to *Conversation—Sky and Earth* an airless silence cloaked in a sense of awe. This was not lost on the author of the accompanying text in *Fortune*, who sensed, in the looming structure of the transmission towers and the wires that stretch up into the blue crystalline firmament, an unmistakable sense of spirituality, noting that it was "truly a religious work of art as any altarpiece, or stained-glass window or vaulted choir."[3] Curiously, Sheeler's approach to the subject paralleled that he took to Chartres Cathedral ten years earlier. The extreme angle, graphic impact, emphasis on detail, and interest in towering, load-bearing structures strongly recall his photograph *Chartres—Flying Buttresses at the Crossing*. Just as Sheeler wondered at the seeming miracle of faith that resulted in Chartres

Notes
1. Karen E. Haas, "Opening the Other Eye: Charles Sheeler and the Uses of Photography," in *The Photography of Charles Sheeler: American Modernist*, by Theodore E. Stebbins, Gilles Mora, and Karen E. Haas (Boston: Bulfinch Press, 2002), 130. Other sites of interest included a steam power plant in Brooklyn and the installation of a turbine engine at the Tennessee Valley Authority plant in Guntersville, Alabama.
2. Theodore E. Stebbins Jr. and Norman Keyes Jr., *Charles Sheeler: The Photographs* (Boston: Little Brown, 1987), 46: "In 1939, before embarking on the Power series, Sheeler told [Edward] Weston that he had bought a 9 x 12 cm. Linhoff, an excellent drop-bed folding camera which he used at Boulder Dam and elsewhere."
3. Reproduced in *Power: Six Paintings by Charles Sheeler*, exh. brochure (New York: Downtown Gallery, December 3–21, 1940).

Fig. 54
Charles Sheeler
Conversation—Sky and Earth, 1940
Cat. no. 63

Charles Sheeler
Conversation—Sky and Earth, 1940

Fig. 55
Charles Sheeler
Winter Window, 1941
Cat. no. 64

Cathedral, Boulder Dam compelled the artist to ponder the mystery inherent in the creation and transmission of hydroelectric power, which moved, unseen, at a speed of 186,000 miles a second.[4] The "power" represented in dam and cathedral both required faith even as they challenged human comprehension of a process far greater than the sum of its physical parts.[5]

Winter Window (fig. 55), in direct contrast to *Conversation—Sky and Earth*, contains no allusions to the industrial or the mechanical, although it too demonstrates the artist's close attention to detail. Here Sheeler set the textures of a plant, terra-cotta pot, and hand-woven textile against those of glass, wood, and paper. Interior is juxtaposed to exterior, and the snow-covered slopes beyond the window emphasize the warmth and security of the foreground interior. The cast shadows of the window's mullions, which are subject to the course of the sun, establish through anticipation the presence of movement, framing this isolated moment within the greater march of linear time.

Sheeler based *Winter Window* on a drawing he dedicated to his wife, Musya Sokolov, dated April 2, 1941, their second wedding anniversary. Both the drawing and the painting were executed at the artist's home in Ridgefield, Connecticut, and the interior depicted in the painting was certainly that of his studio. The exterior alpine vista, however, does not resemble either the landscape surrounding Sheeler's home or Connecticut topography in general. *Winter Window* is thus a pictorial marriage of real and imagined space, and awareness of this fact infuses the work with mystery and suggests an autobiographical reading of the painting as capturing a moment of reverie and reflection in the continuum of Sheeler's life.[6]

It has been suggested that zones of transition such as doors, stairways, and windows in Sheeler's images of his various studios served as the artist's documentation of, or reflection on, significant transitions in his life and career. These depictions of his studio are some of his most self-reflective works and consequently have been variously dubbed "self-portraits," "confessionals,"[7] or, more obliquely, "self-portrait[s] of an artist uncomfortable with self-expression."[8] Before the creation of *Winter Window*, Sheeler had employed the window as the dominant element in two other highly personal compositions: *Self-Portrait* (1926; Museum of Modern Art, New York) and *View of New York* (1931; Museum of Fine Arts, Boston). In these works the window functions as a portal that separates past, present, and future or real and imagined zones—a threshold the crossing of which requires a life-changing choice. Although *Winter Window* separates interior and exterior, the window is, like memory itself, a permeable barrier and symbolic lens through which the artist could survey the events and people that had shaped the topography of his life and his soul.[9]

Patricia Sue Canterbury

4. Ibid., unpaginated. The speed was stated in the text accompanying *Conversation—Sky and Earth*.
5. In 1929 Sheeler visited Chartres. The series of gelatin silver prints, although exceptional in conception and execution, never met with critical acclaim. Sheeler's main interest at Chartres appears to have been the buttresses as the "device[s] that made its size, drama, and interior lighting possible." It was a perfect subject for someone who "was a lifelong student of the sympathetic relationship of faith to form" (Stebbins and Keyes, *Charles Sheeler*, 37–38).
6. James Mahoney Jr., "Charles Sheeler Reveals the Machinery of His Soul," *American Art* 13 (Summer 1999): 48.
7. See Carol Troyen, "Photography, Painting, and Charles Sheeler's *View of New York*," *Art Bulletin* 86 (December 2004): 731. Troyen refers to *View of New York* (1931; Museum of Fine Arts, Boston) as a self-portrait within the tradition of "studio images as confessionals," in which Sheeler documented his decisive career shift away from photography to painting and the uncertainty that attended that choice.
8. Wanda Corn, "Home, Sweet Home," in *The Great American Thing: Modern Art and National Identity, 1915–1935* (Berkeley, Los Angeles, and London: University of California Press, 1999), 337. Corn applied this phrase to Sheeler's painting of his South Salem, New York, studio, *Home, Sweet Home* (1931; Detroit Institute of Arts).
9. See Mahoney, "Charles Sheeler Reveals," 49, wherein he states that *Winter Window* is "a self-portrait commemorating the artist's abandonment of Doylestown, the passage of time since the death of Katharine, and the second anniversary of his marriage to Musya. It is thus a summing up of the important personal events in his life." Mahoney applies classic iconographic analysis to the objects and motifs to arrive at this interpretation.

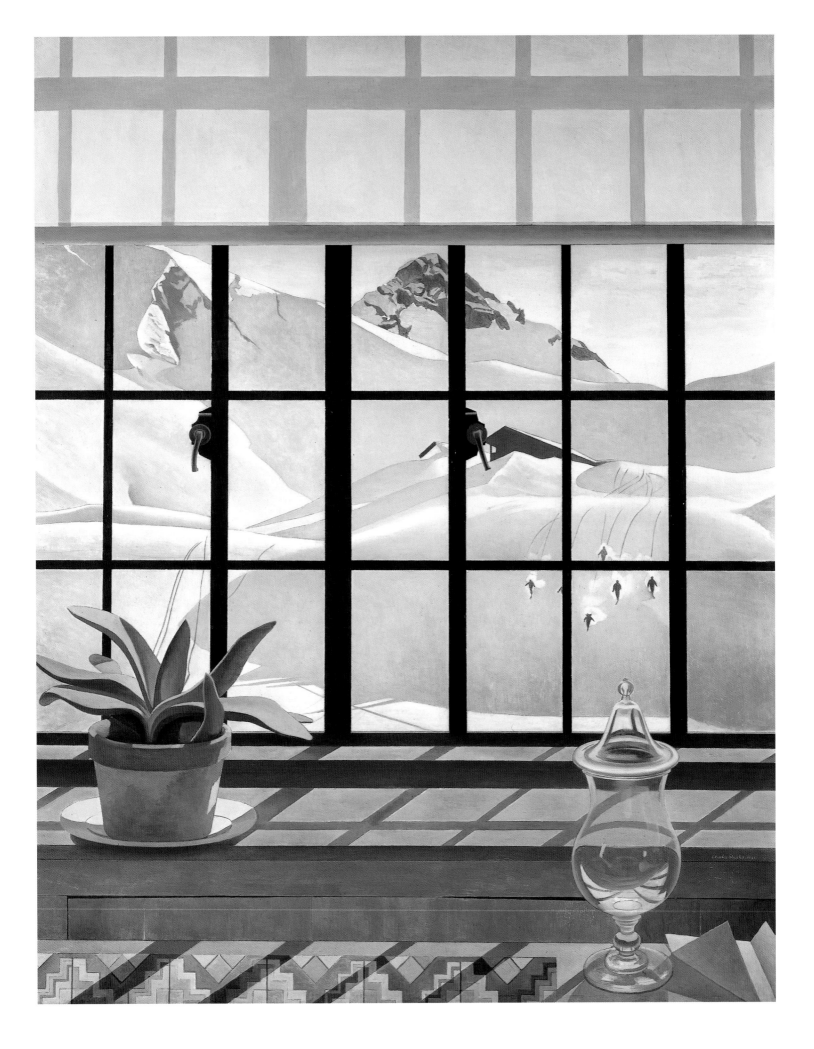

Romare Bearden
Folk Musicians, 1941–42

Folk Musicians is one of several works—all in gouache on brown paper—that Romare Bearden executed during late 1941 and early 1942 to fulfill a commission from *Forbes* magazine. Although a companion composition entitled *Factory Workers* (fig. 56) was selected to accompany an essay entitled "The Negro's War" for *Forbes*'s June 1942 issue,[1] the two gouaches reveal a dialogue in scale, setting, palette, and technique that could qualify them as pendant works. At the very least, they form ellipses that embrace a poignant document of the discrimination and unfair labor practices that plagued African Americans in their transition from agrarian to industrialized environments in the period leading up to, and including, the early years of World War II. Both works, crisply drawn, are as hard-edged as the subjects they portray, and the gritty texture of their urban environment is echoed in the optical qualities of the dry, porous gouache.

Certainly this transition from rural to urban, and the frustration that accompanied being caught between those two worlds and not fully belonging to either, are at the heart of *Folk Musicians*. The landscape at left, blighted and dotted with blasted trees, offers no compelling reason to retreat. Bearden, however, offers no route of escape and instead compresses the men into the foreground and against the picture plane through judicious cropping. He traps them in the visual equivalent of a dead end and confronts us with the predicament of those who, although physically able and willing to work, are forced by racism and lack of opportunity to survive by whatever means are available to them. Their hopelessness, resignation, and weariness are palpable.

Bearden had embraced the use of art as a tool of conscience to probe, expose, and ridicule social injustice shortly after arriving at college in 1929 and eventually articulated his views on the subject in 1934, when he publicly chastised black artists for failing to use their art to address contemporary social issues.[2] His convictions on this matter were echoed in the art world at large during the first half of the twentieth century, and prime examples of Social Realist painting by artists such as Ben Shahn and Jacob Lawrence would have been available to him. In terms of the artistic aesthetic of *Folk Musicians* and related compositions of the early 1940s, however, it is generally agreed that the Mexican muralists, whose works were characterized by their heroic presentation and reliance on interlocking planes of color, were Bearden's inspirational touchstone.[3]

Patricia Sue Canterbury

Notes
1. The vertical format of *Factory Workers* would have been better suited to the full-page reproduction.
2. H. R. Bearden, "The Negro Artist and Modern Art," in *Opportunity: A Journal of Negro Life*, December 1934.
3. See Ruth Fine, "Romare Bearden: Between the Spaces," in *The Art of Romare Bearden* (Washington, D.C.: National Gallery of Art, 2003), 11. Fine notes that the Museum of Modern Art presented a Diego Rivera exhibition in 1935; that David Alfaro Sequeiros resided in New York City during 1936 and 1937, establishing an experimental workshop to which many WPA artists flocked, possibly including Bearden; and that Rufino Tamayo, whom Bearden particularly admired, became a permanent resident of New York City in 1936.

Fig. 56
Romare Bearden
Factory Workers, 1942
Gouache and casein on brown paper
37 3/8 x 33 1/2 in. (94.9 x 85.1 cm)
The Minneapolis Institute of Arts, The John R.
Van Derlip Fund

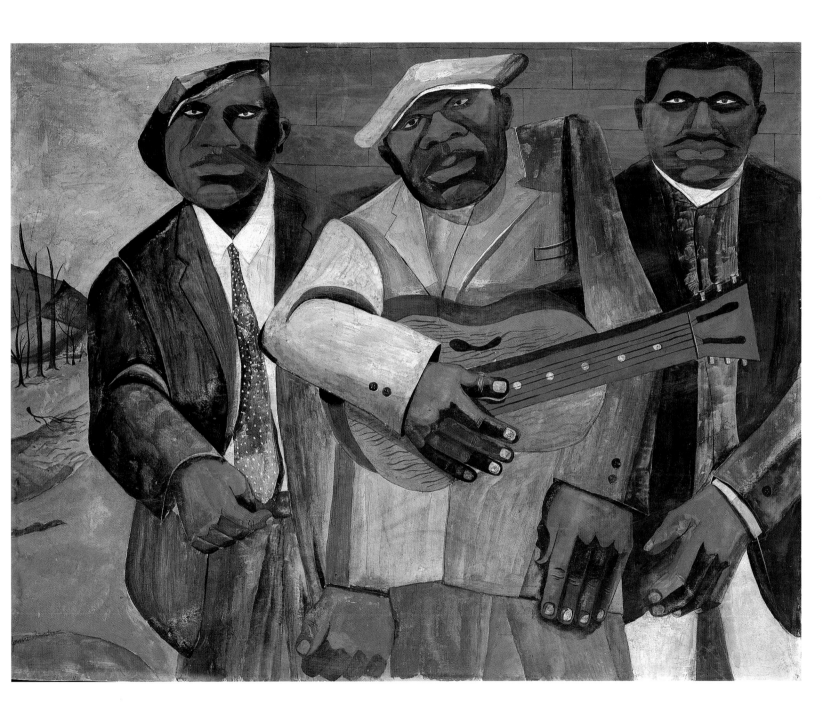

Fig. 57
Romare Bearden
Folk Musicians, 1941–42
Cat. no. 2

Philip Guston
Halloween Party, 1942

Halloween Party is an early product from a period of significant transition on several levels in the life and work of Philip Guston. In spite of the fact that the artist had achieved success with several public mural projects in Los Angeles, Mexico, and New York City during the 1930s, his fascination with social commentary on a monumental scale had flagged by 1940. He would later recall: "I didn't feel strong conviction about the kind of figuration I'd been doing for about eight years. . . . I entered a bad, painful period when I had lost what I'd had and had nowhere to go. I was in a state of dismantling."[1] Thus, when he was offered the post of artist-in-residence at the University of Iowa for the fall of 1941, the artist embraced it as an opportunity that would allow him the time and space to step back, to reassess, and to discern his future course.

Relocation to the Midwest for one who had known and identified with only the urban environments of Los Angeles and New York City, while accompanied by culture shock, removed Guston from the urban social issues and themes that had been the stock of his art prior to that time. The theme of child's play was one of the elements that he allowed to migrate with him. The brick walls and discarded debris of impromptu urban playgrounds were reconceived in Iowa City in a visual vernacular more sympathetic to small-town life and its customs. Consequently, key elements in setting the scene in *Halloween Party* are plant forms, unpaved surfaces, and the inclusion of a low fence composed of irregularly shaped stones gathered from surrounding fields and streambeds.[2]

In *Halloween Party*, the custom of beggar's night, with children roaming the community's streets under the cover of darkness, was a point of fascination for the artist. He also captured the comical irony implicit in costumed children who, though desirous of being feared as wild creatures or goblins, remain afraid of their own shadows. Standing in a cluster, each child betrays his or her insecurity in relationship to a threat perceived beyond the limits of the composition: the little girl who seeks reassurance in the hand of her older brother, the boy cum tiger who hesitantly probes the darkness with a shout, and the young boy dressed in red clothes and hat—evocative of a court jester or fool—who seeks security in the recesses of his nose. The latter figure (being the only one to look at us directly) could be one of Guston's earliest instances during the decade in which he included himself in works of increasing autobiographical and symbolic complexity and, therefore, may constitute a psychological self-portrait created during a very insecure period in the artist's professional life.[3]

Patricia Sue Canterbury

Notes

1. Dore Ashton, *A Critical Study of Philip Guston* (Berkeley: University of California Press, 1990), 62.

2. The only other instance known by this author in which a stone fence is used to signify the rural or agrarian space appears in a work that was executed concurrently with *Halloween Party*—a mural commission based on the theme of "Reconstruction and the Well-Being of Family" for the Social Security Board Building in Washington, D.C. See Michael Shapiro, *Philip Guston: Working through the Forties* (Iowa City: University of Iowa Museum of Art, 1997), 6, for an illustration of the cartoon for the mural commission.

3. Ibid., 8–10. Shapiro remarks upon Guston's tendency toward self-reference and/or self-representation in *Sanctuary* (1944), *Holiday* (1944), *If This Be Not I* (1945), *The Porch* (1946–47), and *The Porch II* (1947).

Fig. 58
Philip Guston
Halloween Party, 1942
Cat. no. 31

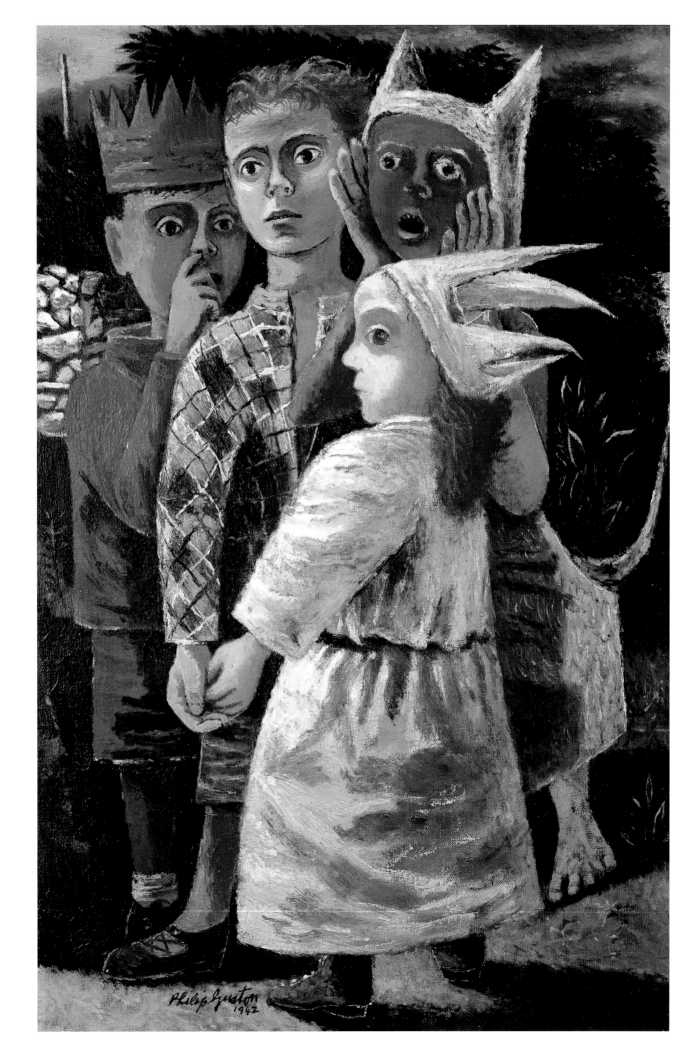

Walt Kuhn
Roberto, 1946

During the 1940s a plague of clowns descended upon American art. For reasons that are still mysterious, many artists of talent—and virtually all of those without any—felt compelled to try their hand at painting sad clowns, happy clowns, or the existential ambiguities of clowndom. The exact origins of this iconographic pestilence are still unclear, but they were, most likely, related to a renewed upsurge in popularity of circuses and vaudeville immediately following the end of World War II, just before television, Bozo, and Art Carney permanently sidelined Grock and the enticements of big-tent America. Hollywood, sensing a trend, for a while staged melodramas about the tribulations of famous clowns. The omnipresence of these tortured creatures in the nation's galleries during the 1940s and early 1950s thus almost certainly became a contributing factor in the rapid popularization of abstraction among our postwar intelligentsia.

Walt Kuhn was not to blame for this development. He had been painting clowns, show-girls, jugglers, vaudevillians, and trapeze artists since the early years of the century, and his *Roberto,* painted only a few years before his death, is the fruit of a careerlong fascination with the milieu of performers. Though also painted in the 1940s, it is a character study of remarkable complexity and subtlety, far removed from the often maudlin superficiality that made the work of so many others end up as decorations in seedy motels. One of the original organizers of the famous Armory Show of 1913, Kuhn had clearly honed his craft dramatically by the time he painted *Roberto.* There is a three-dimensional monumentality, physical tension, and force of execution in his treatment of this athletic circus performer that gives Kuhn's portrait of the man a remarkable psychological presence. Even his being captured in whiteface for once enhances this quality. A similar effect, also working against traditional expectations, comes from the way the pink of the man's tights serves to reinforce rather than drain our sense of his muscular strength.

Most of Kuhn's earlier work had dealt with his subjects in a rather generic and anec-dotal fashion, gaining its interest primarily from the simplified modernism of sketchily delineated figures. His charming but nondescript portrait of the young Angna Enters (fig. 61), for instance—painted more than twenty years earlier, when she must have been all of seventeen—gives little indication of her youth or of her remarkable talents, which would take her from her start as a "mime dancer" to international acclaim as a multitalented theater designer, artist, illustrator, author, and Guggenheim Fellow.

Fig. 59
Walt Kuhn
Roberto, 1946
Cat. no. 39

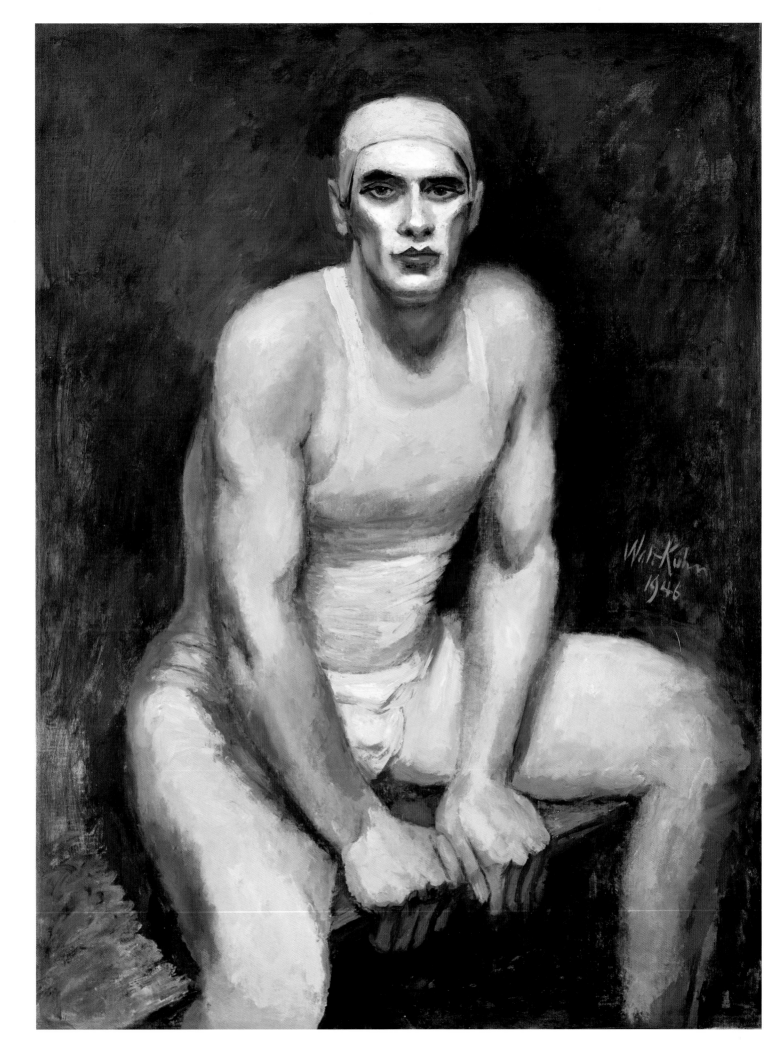

Walt Kuhn
Roberto, 1946

Kuhn was well aware that *Roberto* had taken his work to a new level. As Philip Rhys Adams reported in 1960, "when it was shown in 1946 it brought the highest price Walt Kuhn had ever received; [at $5,500] it was then one of the highest prices ever paid for a living American's work."[1] Midcentury critics such as Emily Genauer embraced it as "possibly his greatest picture in a series on people of the circus."[2] And in 1949 Oliver Larkin, in his monumental *Art and Life in America,* associated *Roberto* with "the power of a [Marsden] Hartley."[3] Thus, when Kuhn died that year, his career, unlike those of most of his contemporaries, who lost the greater part of their reputations in the postwar onslaught of abstract painting, ended with a bang, not a whimper.

Bram Dijkstra

Notes
1. Philip Rhys Adams, "An Introduction to the Artist," in *Walt Kuhn, 1877–1949: A Memorial Exhibition* (Cincinnati: Cincinnati Art Museum, 1960), unpaged.
2. Emily Genauer, *Best of Art* (Garden City, N.Y.: Doubleday, 1948), 138.
3. Oliver W. Larkin, *Art and Life in America* (New York: Rinehart, 1949), 452.

Fig. 60
Walt Kuhn
Superba, 1926
Oil on canvas
39 x 25 in. (99.1 x 63.5 in.)
Collection of Curtis Galleries, Inc.,
founder Myron Kunin

Fig. 61
Walt Kuhn
Angna Enters, 1924
Cat. no. 38

Alice Neel
Young Woman, 1946

Alice Neel intrepidly reclaimed portraiture, a genre deemed exhausted by American modernists. Bringing the figure forward into the viewer's space, she confronted the prevailing theories of the "sexual" body while delving into the interior territory of the ego. "Before painting," she remarked, "when I talk to the person, they unconsciously assume their most characteristic pose, which in a way involves all their character and social standing—what the world has done to them and their retaliation."[1]

Neel's sitters ranged from the notable to the unknown, including family members, artists and intellectuals from Greenwich Village, neighbors in Spanish Harlem, a New York City mayor, and even an archbishop. In the 1930s she received commissions from the Works Progress Administration, and her portraits espouse the program's democratic goal of portraying American society in all its individuality and variety. Although she has been championed for her social critique, Neel remained reluctant to align herself with the ideal of a collective art, be it in the service of communism or feminism.[2] Her images are poignant and raw but decisively individual.

In 1938 Neel moved with her two children to Spanish Harlem, a Manhattan neighborhood populated largely by Puerto Ricans, Cubans, and Dominicans. In contrast to the Social Realist artists of the day, who placed their subjects in narratives of alienation often set in crowded urban landscapes, Neel focused on the families she met in Spanish Harlem's deteriorating tenement buildings. It has been argued that Neel, painting in her home studio, acknowledged the private confines of poverty by depicting the lived-in, domestic space of her subjects.[3] By examining society as reflected in the subjectivity of the human body, she aspired to "paint my time using the people as evidence."[4]

Young Woman, painted in 1946, is from Neel's Spanish Harlem series. A woman of similar appearance is portrayed with her children in *The Spanish Family* (1943). In the 1946 canvas the woman is the central focus, and she is positioned against a decorative background of repeating linear patterns, which collapses spatial depth. This compression of background and foreground suggests the influence of Henri Matisse, while Neel's hot colors and crude application of paint hark back to the German Expressionists.

Although not a nude portrait, *Young Woman* reveals Neel's concern for the body as a social construct, a tense intertwining of appearance, subjugation, and self-knowledge. A small triangular form under the subject's left eye evokes a Rembrandtesque lighting effect, yet here the technique is marred, and a flattering geometry of light collapses into an imbalanced, degenerate form. As if in defense of the pictorial violation, a sinister smudge of red paint is applied below the woman's eye, forming a swelling bruise of the same hue as her full lips, so that the marker of femininity accentuates the act of violence. References to physical abuse occur in other paintings by Neel.[5] The unsettling quality of this imagery is reinforced by a heavy shadow that resembles the dark form lurking at the girl's side in Edvard Munch's *Puberty* of 1894. But whereas in Munch's painting this motif alludes to the anxieties of adolescence, in Neel's portrait it suggests the vicissitudes of adulthood.

Dana Simpson

Notes
1. Patricia Hills, *Alice Neel* (New York: Harry N. Abrams, 1983), 189.
2. Ibid., 124.
3. Pamela Alara, *Pictures of People* (Hanover, N.H.: University Press of New England, 1998), 151.
4. Carolyn Carr, *Alice Neel: Women* (New York: Rizzoli, 2002), 47.
5. See discussion in Hills, *Alice Neel*, 260–61.

Fig. 62
Alice Neel
Young Woman, 1946
Cat. no. 47

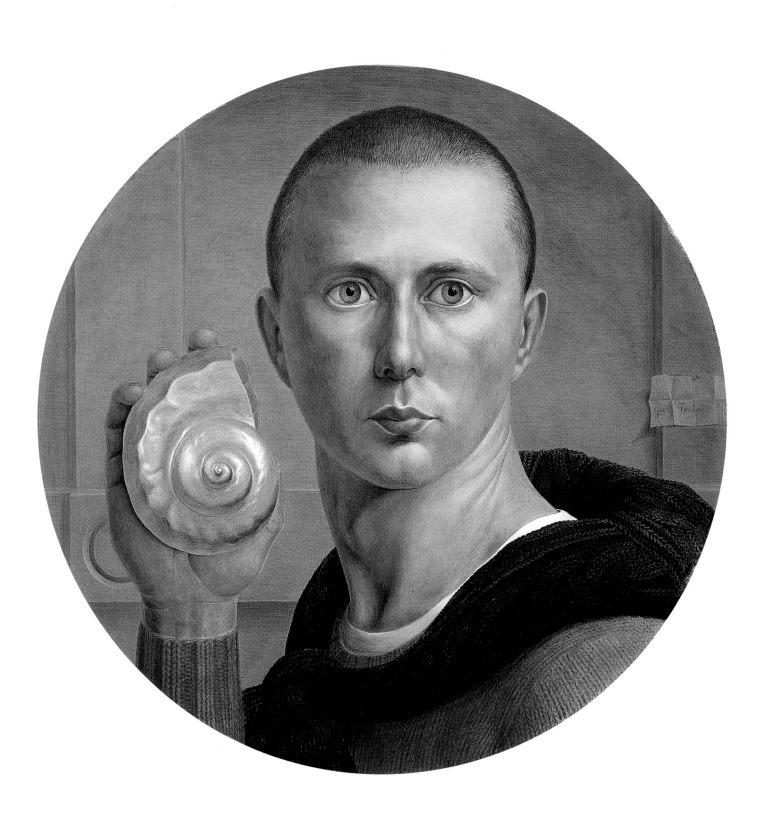

George Tooker
Self-Portrait, 1947

Notes

1. Thomas Garver, *George Tooker* (New York: Clarkson N. Potter, 1985), 10.
2. For a more complex reading of the sense of anxiety in Tooker's paintings, see Katherine Hauser, "George Tooker, Surveillance, and Cold War Sexual Politics," *GLQ: A Journal of Gay and Lesbian Studies* 11 (June 2005): 391–426.
3. Stephen Robert Frankel, "The Modern Iconography of George Tooker," *Art Today* 1 (Summer 1986): 19–20.
4. Garver, *George Tooker,* 18.
5. Ibid.

George Tooker, like the Magic Realists, pursued an almost photographic natural-ism in his paintings, but although he has often been associated with the style, he was not persuaded by the aesthetic of fantasy espoused by its practitioners. "I am after painting reality impressed on the mind so hard it returns as a dream," Tooker has explained, "but I am not after painting dreams as such, or fantasy."[1] His trenchant social commentary, most remarkable in his depictions from the 1950s of subway tunnels and bureaucratic mazes but also evident in later works such as *The Super-market* (1972; cat. no. 73), transforms individual anguish into a universal burden.[2] To sharpen such themes, Tooker frequently repeated figures within a single work.

Although many of the male figures in Tooker's paintings bear a resemblance to the artist himself, he completed only three formal self-portraits. The example in the Kunin collection, dated 1947, is the earliest of them.[3] A restrained sensibility and decorative expressiveness point to the influence of Italian Mannerist Agnolo Bronzino. Painted on a small panel with the care of a miniaturist, the self-portrait is executed in the painstaking medium of egg tempera, a sixteenth-century technique that Tooker had learned from his friend and mentor, the artist Paul Cadmus. After transferring the outlines of the drawing to a panel, Tooker methodically applied powdered pigment and egg yolk, building layer upon layer of color.

It is alleged that the purchase of a round black frame, reminiscent of seventeenth-century Dutch examples, inspired the artist to choose the portrait's tondo format.[4] Many elements of the self-portrait suggest an interest in applying the techniques and imagery of old master painting to contemporary subject matter. This interest is also evident in *Coney Island* of 1948 (fig. 65), likewise painted in egg tempera, which features a Pietà grouping in the foreground.

Beginning the portrait in his Manhattan studio, Tooker carried it with him to Province-town, where he spent the summer with Cadmus. A severely cropped haircut, the re-sult of a barber's inattention, introduced a serendipitous element to the work. Reclaim-ing the "mistake," Tooker was inspired to capture his accentuated facial structure. The artist's limpid blue eyes, the smooth curve of his head, and the circular design of the wood molding distinguish the self-portrait as a study of circular volumes.[5]

Fig. 63
George Tooker
Self-Portrait, 1947
Cat. no. 71

George Tooker
Self-Portrait, 1947

Frustrating this order, a large nautilus shell refuses to enclose its radiating spiral. The proximity of the iridescent shell to the artist's assertive countenance suggests that the object carries symbolic significance. As an object often referenced in the works of the Surrealists, the shell imbues the portrait with deeper allusions to the subconscious. The polished carapace pulls the viewer toward its unrelenting spiral as if to divert attention from the eyes of the artist. Tooker's index finger appears to fuse and intermingle with the shell's curving channels, its rosy interior indistinguishable from his embracing hand. Furthermore, the ratio of each rotation of the shell represents a distinct proportion and thus parallels similar proportions measurable in the human body. The comparison of shell to face alludes to the universal structures shared by man and nature.

From the woven yarn of the artist's sweater to the sharp crop of his hair, details are rendered with astonishing acuity. Despite the painting's luminous clarity, the formal elements are obscure. The drape of a sweater, tied rather fashionably about the neck, resembles the cowl of a Renaissance prince. Set against a bright white shirt, the sweater's dark bulk might also suggest the robe of a monk. Each element of dress opens intriguing metaphors about the persona of the artist and the interpretive depth of the self-portrait. In a final gesture, Tooker inscribed his signature on a scrap of paper, unfixing the defining marker of authorship.

Dana Simpson

Fig. 64
George Tooker
The Entertainers, 1959
Tempera on Masonite
20 x 24 in. (50.8 x 60.1 cm)
Collection of Curtis Galleries, Inc.,
founder Myron Kunin

Fig. 65
George Tooker
Coney Island, 1948
Cat. no. 72

Illustrated Checklist of the Exhibition

Note: All works are from the collection of Curtis Galleries, Inc.,
founder Myron Kunin

MILTON AVERY

Born SAND BANK, NEW YORK, 1885
Died NEW YORK CITY, 1965

1. *Seated Nude,* 1940
Oil on canvas
48 x 32 in. (121.9 x 81.3 cm)

ROMARE BEARDEN

Born CHARLOTTE, NORTH CAROLINA, 1911
Died NEW YORK CITY 1988

2. *Folk Musicians*, 1941–42
Gouache and casein on brown paper
35 1/2 x 45 1/2 in. (90.2 x 115.6 cm)

ELMER NELSON BISCHOFF

Born BERKELEY, CALIFORNIA, 1916
Died BERKELEY, CALIFORNIA, 1991

3. *Hangover Club*, 1953
Oil on canvas
69 x 57 in. (175.3 x 144.8 cm)

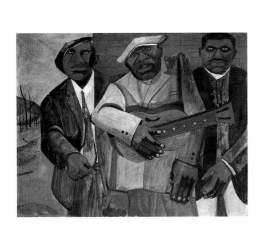

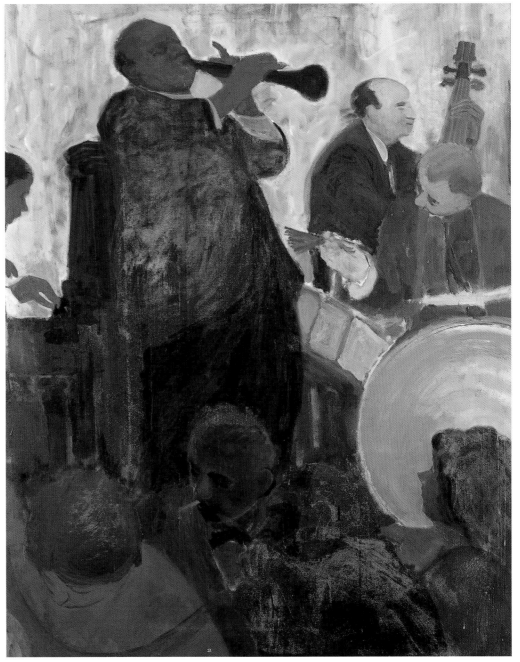

OSCAR BLUEMNER

Born PRENZLAU, GERMANY, 1867
Died SOUTH BRAINTREE, MASSACHUSETTS, 1938

4. *Illusion of Prairie, N.J. (Red Farm at Pochuck)*, 1914
Oil on canvas
30 x 40 in. (76.2 x 101.6 cm)

5. *Self-Portrait*, 1933
Oil on board
19 3/4 x 14 3/4 in. (50.2 x 37.5 cm)

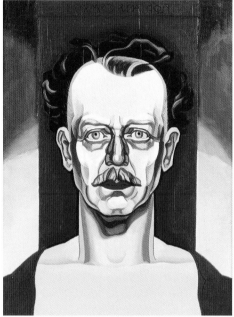

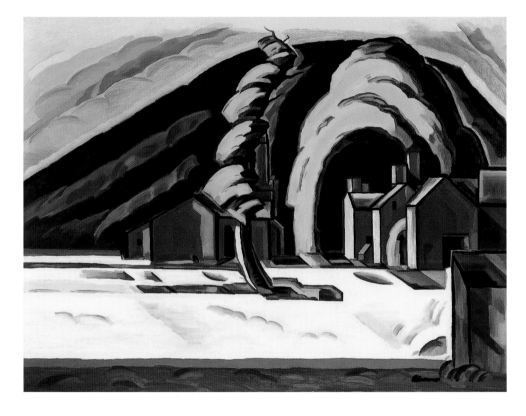

6. *Maine Coast*, 1926
Oil on canvas
40 x 30 in. (101.6 x 76.2 cm)

7. *Peggy Bacon on Sofa*, 1922
Oil on canvas
30 x 36 in. (76.2 x 91.4 cm)

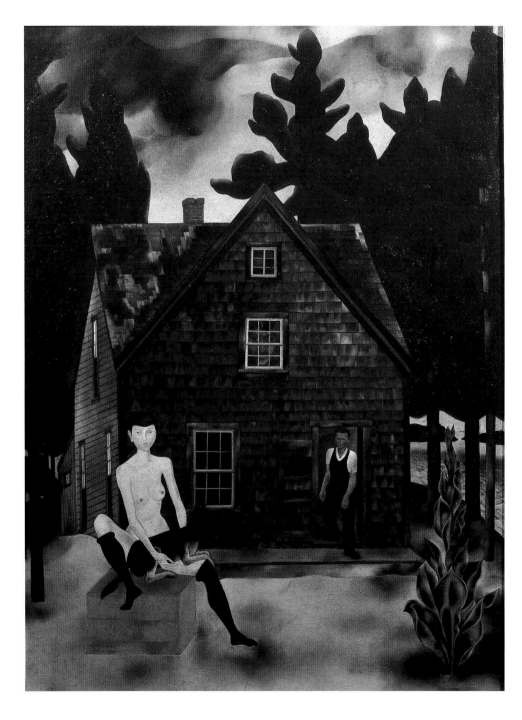

8. *Portrait of Raphael Soyer*, 1929
Oil on canvas
61 1/2 x 36 1/2 in. (156.2 x 92.7 cm)

9. *Self-Portrait*, 1935
Tempera on Masonite
16 x 12 in. (40.6 x 30.5 cm)

10. *Aspects of Suburban Life: Main Street*, 1937
Oil and tempera on board
31 3/4 x 73 3/8 in. (80.7 x 186.4 cm)

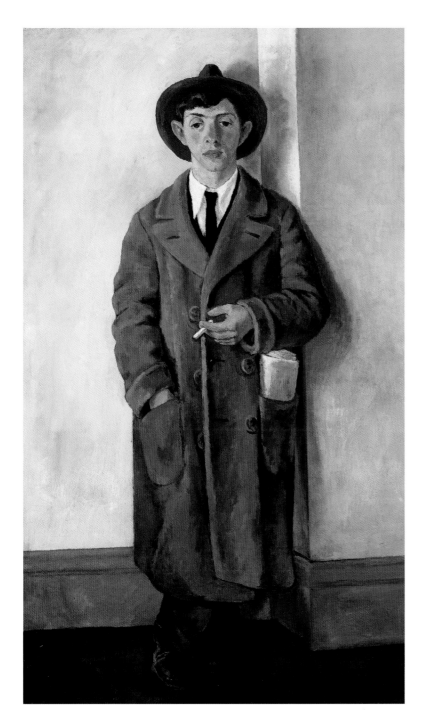

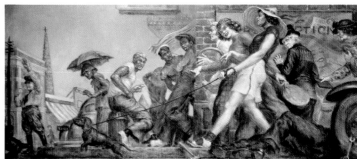

ARTHUR B. CARLES

Born PHILADELPHIA 1882
Died PHILADELPHIA 1952

11. *Self-Portrait in Front of Striped Cloth*, c. 1915
Oil on canvas
24 1/2 x 25 in. (62.2 x 63.5 cm)

12. *Nude Reclining*, 1921
Oil on canvas
26 x 29 1/2 in. (66 x 74.9 cm)

RALSTON CRAWFORD

Born SAINT CATHERINES, CANADA, 1906
Died HOUSTON, TEXAS, 1978

13. *Water Tank*, 1937
Oil on canvas
30 x 36 in. (76.2 x 91.4 cm)

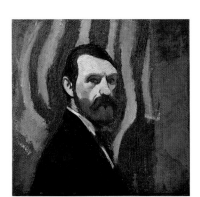

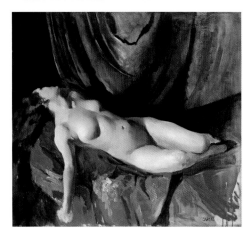

JOHN STEUART CURRY

Born NEAR DUNAVANT, KANSAS, 1897
Died MADISON, WISCONSIN, 1946

14. *The Flying Codonas*, 1933
Oil on canvas
36 x 30 in. (91.4 x 76.2 cm)

15. *Self-Portrait*, 1935
Oil on panel
30 1/4 x 25 1/8 in. (76.8 x 79.1 cm)

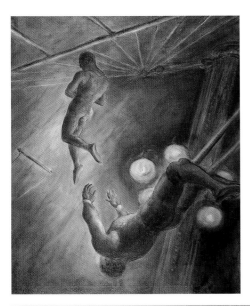

STUART DAVIS

Born PHILADELPHIA 1894
Died NEW YORK 1964

16. *Self-Portrait*, 1912
Oil on canvas
32 1/4 x 26 1/4 in. (81.9 x 66.7 cm)

17. *Ebb Tide, Provincetown (Man on the Beach)*, 1913
Oil on canvas
38 x 30 in. (96.5 x 76.2 cm)

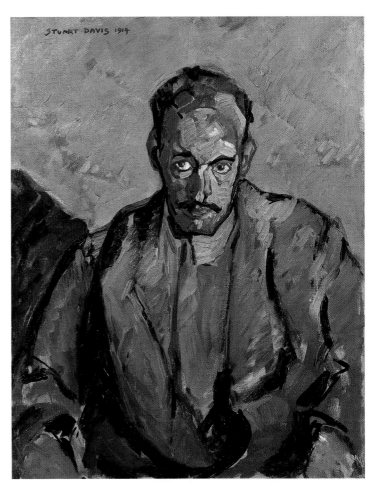

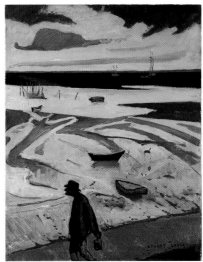

18. *Portrait of a Man*, 1914
Oil on canvas
30 x 23 3/4 in. (76.2 x 60.3)

19. *Study for Eggbeater No. 5*, 1930
Gouache on paper
22 x 14 in. (55.9 x 35.6 cm)

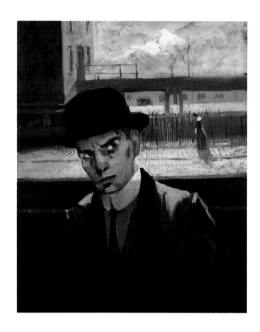

CHARLES DEMUTH

Born LANCASTER, PENNSYLVANIA, 1883
Died LANCASTER, PENNSYLVANIA, 1935

20. *Sail in Two Movements*, 1919
Gouache on paper
16 x 20 in. (40.6 x 50.8 cm)

21. *Three Plays—Stockbridge*, 1926
Tempera on board
25 x 20 1/2 in. (63.5 x 52.1 cm)

EDWIN DICKINSON

Born SENECA FALLS, NEW YORK, 1891
Died ORLEANS, MASSACHUSETTS, 1978

22. *Helen Souza*, 1925
Oil on board
36 x 30 in. (91.4 x 76.2 cm)

ARTHUR DOVE

Born CANANDAIGUA, NEW YORK, 1880
Died HUNTINGTON, NEW YORK, 1946

23. *Moon and Sea II*, 1923
Oil on canvas
24 x 18 in. (61 x 45.7 cm)

24. *Dancing Tree*, 1930
Oil and wax emulsion on board
30 x 40 in. (76.2 x 101.6 cm)

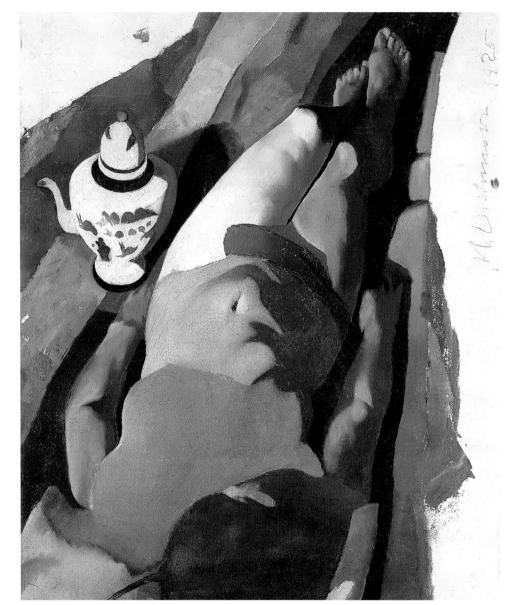

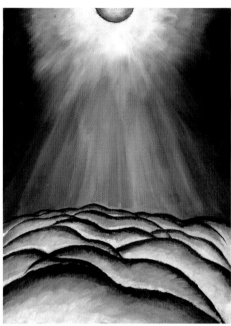

PHILIP EVERGOOD

Born NEW YORK CITY 1901
Died BRIDGEWATER, CONNECTICUT, 1973

25. *Madonna of the Mines*, 1932
Oil on canvas
50 1/4 x 30 in. (127.6 x 76.2 cm)

26. *Nude with Violin*, 1957
Oil on canvas
45 x 30 in. (114.3 x 76.2 cm)

27. *Self-Portrait*, 1957
Oil on canvas
15 1/2 x 12 in. (39.4 x 30.5 cm)

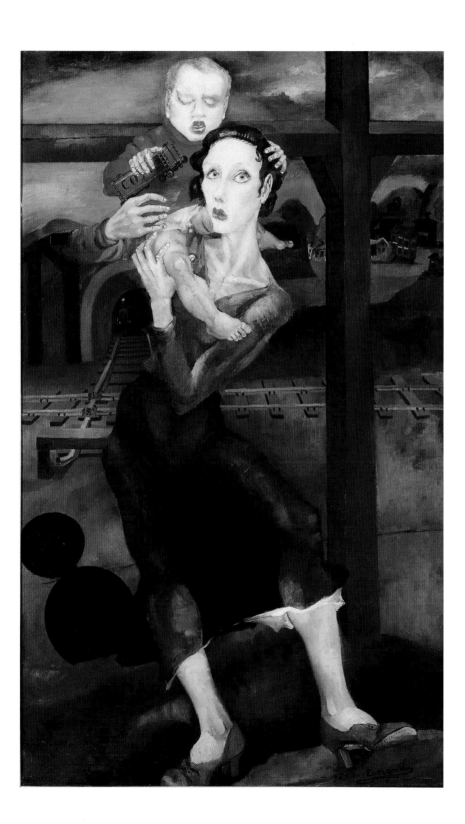

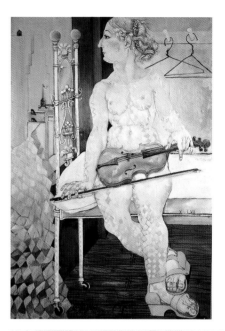

JARED FRENCH

Born OSSINING, NEW YORK, 1905
Died ROME 1988

28. *Evasion*, 1947
Egg tempera on gessoed panel
21 1/2 x 11 1/4 in. (54.6 x 28.6 cm)

ARNOLD FRIEDMAN

Born NEW YORK CITY 1874
Died NEW YORK CITY 1946

29. *Self-Portrait in Profile*, 1936–38
Oil on canvas
27 3/4 x 23 in. (70.5 x 58.4 cm)

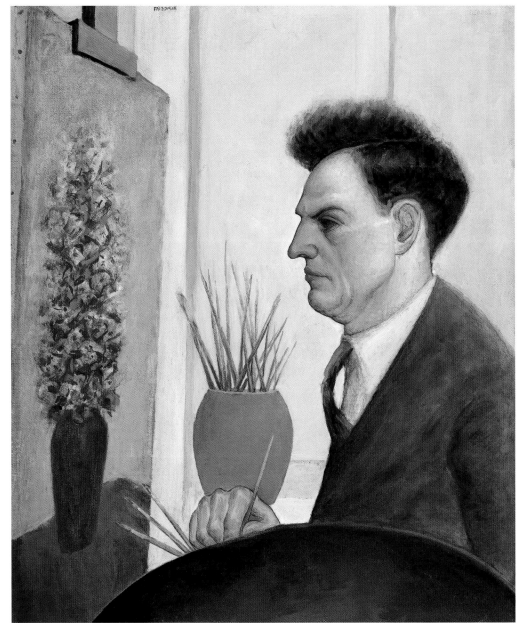

NAUM GABO

Born KLIMOVICHI, BELARUS, 1890
Died WATERBURY, CONNECTICUT, 1977

30. *Constructed Head No. 2*, 1916
Galvanized steel
17 1/4 x 17 x 17 in. (43.8 x 43.2 x 43.2 cm)

PHILIP GUSTON

Born MONTREAL, CANADA, 1913
Died WOODSTOCK, NEW YORK, 1980

31. *Halloween Party*, 1942
Oil on canvas
24 x 16 in. (61 x 40.6 cm)

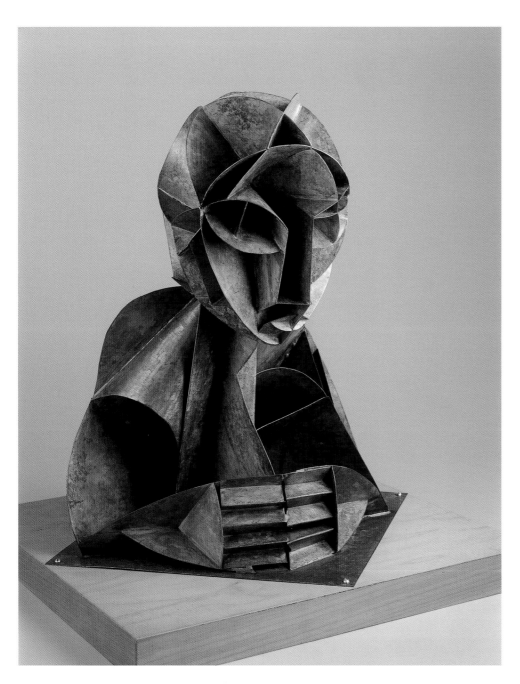

MARSDEN HARTLEY

Born LEWISTON, MAINE, 1877
Died ELLSWORTH, MAINE, 1943

32. *A Nice Time*, 1915
Oil on board
24 x 20 in. (61 x 50.8 cm)

33. *The Embittered Afternoon of November, Dogtown*, 1931
Oil on board
18 x 24 1/4 in. (45.7 x 61.6 cm)

34. *Madawaska—Acadian Light-Heavy*, 1940
Oil on canvas
40 x 30 in. (101.6 x 76.2 cm)

35. *Prayer on Park Avenue*, 1942
Oil on panel
40 x 30 in. (101.6 x 76.2 cm)

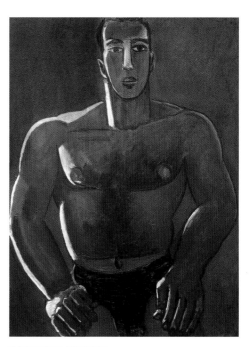

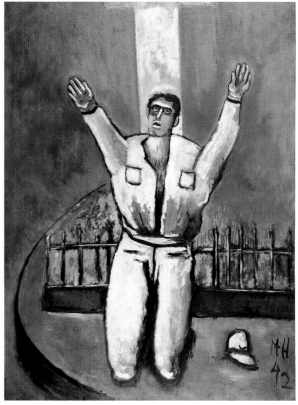

ROBERT HENRI

Born CINCINNATI, OHIO, 1865
Died NEW YORK CITY 1929

STEFAN HIRSCH

Born NUREMBERG, GERMANY, 1899
Died NEW YORK CITY 1964

36. *Edna Smith (The Sunday Shawl)*, 1915
Oil on canvas
41 x 33 in. (104.1 x 83.8 cm)

37. *Night Terminal 1929*, 1929
Oil on canvas
22 3/8 x 29 1/4 in. (56.8 x 74.3 cm)

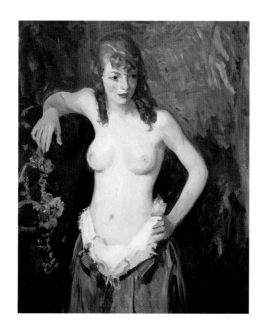

WALT KUHN

Born BROOKLYN 1877
Died WHITE PLAINS, NEW YORK, 1949

38. *Angna Enters*, 1924
Oil on canvas
33 x 22 in. (83.8 x 55.9 cm)

39. *Roberto*, 1946
Oil on canvas
40 x 30 in. (101.6 x 76.2 cm)

YASUO KUNIYOSHI

Born OKAYAMA, JAPAN, 1889
Died NEW YORK CITY 1953

40. *Girl and Barnyard Animals*, 1922
Oil on canvas
20 x 16 in. (50.8 x 40.6 cm)

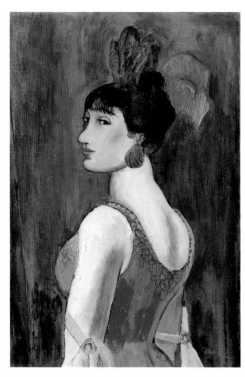

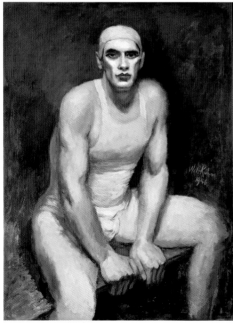

RICHARD LINDNER

Born HAMBURG, GERMANY, 1901
Died NEW YORK CITY 1978

41. *Woman in a Corset*, 1951
Oil on canvas
39 3/4 x 20 1/4 in. (101 x 51.4 cm)

GEORGE LUKS

Born WILLIAMSPORT, PENNSYLVANIA, 1867
Died NEW YORK CITY 1933

42. *Reclining Nude (My Favorite Model)*, n.d.
Oil on wood panel
16 x 20 in. (40.6 x 50.8 cm)

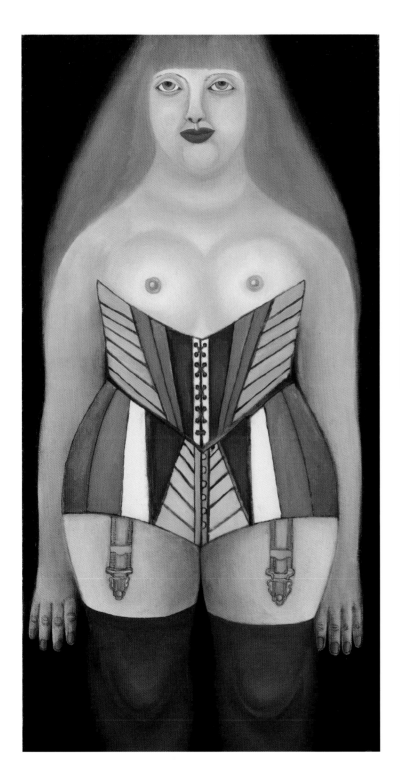

REGINALD MARSH

Born PARIS 1898
Died NEW YORK CITY 1954

43. *Star Burlesque*, 1933
Tempera on Masonite
48 x 36 in. (121.9 x 91.4 cm)

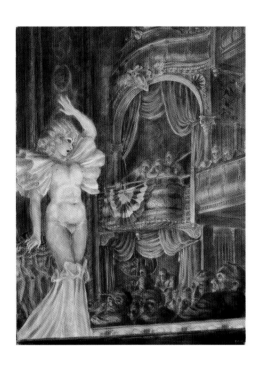

ALFRED MAURER

Born NEW YORK CITY 1868
Died NEW YORK CITY 1932

44. *Head of a Woman (Fauve Head)*, 1908
Oil on Masonite
18 x 15 in. (45.7 x 38.1 cm)

GERALD MURPHY

Born BOSTON 1888
Died EAST HAMPTON, NEW YORK, 1964

45. *Villa America*, c. 1924
Tempera and gold leaf on canvas
14 1/2 x 21 1/2 in. (36.8 x 54.6 cm)

46. *Doves*, 1925
Oil on canvas
48 5/8 x 36 in. (123.5 x 91.4 cm)

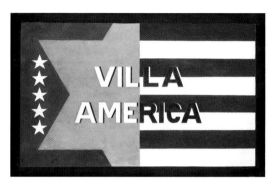

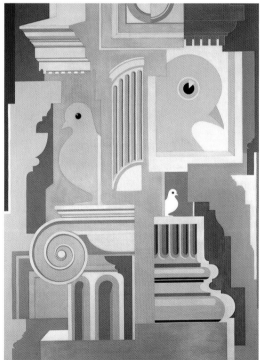

ALICE NEEL

Born MERION SQUARE, PENNSYLVANIA, 1900
Died NEW YORK CITY 1984

47. *Young Woman*, 1946
Oil on canvas
32 x 24 in. (81.3 x 61 cm)

GEORGIA O'KEEFFE

Born SUN PRAIRIE, WISCONSIN, 1887
Died SANTA FE, NEW MEXICO, 1986

48. *Shelton Hotel, N.Y. No. 1*, 1926
Oil on canvas
32 x 17 in. (81.3 x 43.2 cm)

49. *Green-Grey Abstraction*, 1931
Oil on canvas
36 x 24 in. (91.4 x 61 cm)

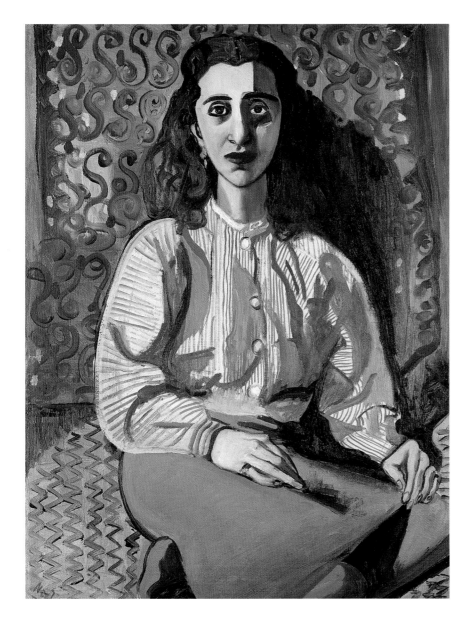

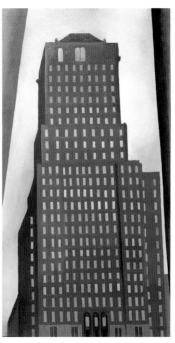

DAVID PARK

Born BOSTON 1911
Died BERKELEY, CALIFORNIA, 1960

50. *Ball Game on Beach*, 1953
Oil on canvas
38 1/4 x 49 1/4 in. (97.2 x 125.1 cm)

GUY PÈNE DU BOIS

Born BROOKLYN 1884
Died BOSTON 1958

51. *The Sisters*, 1919
Oil on panel
20 x 15 in. (50.8 x 38.1 cm)

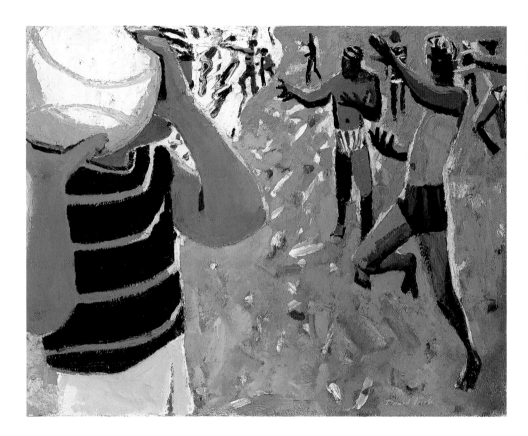

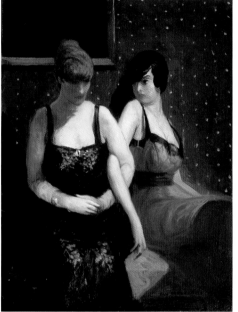

52. *Absinthe House, New Orleans*, 1946
Oil on canvas
26 x 32 in. (66 x 81.3 cm)

53. *Nude—Red Hair*, 1946
Oil on board
19 1/2 x 14 1/2 in. (49.5 x 36.8 cm)

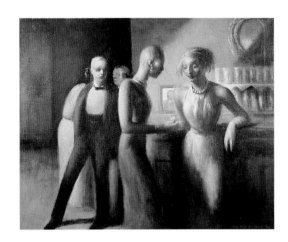

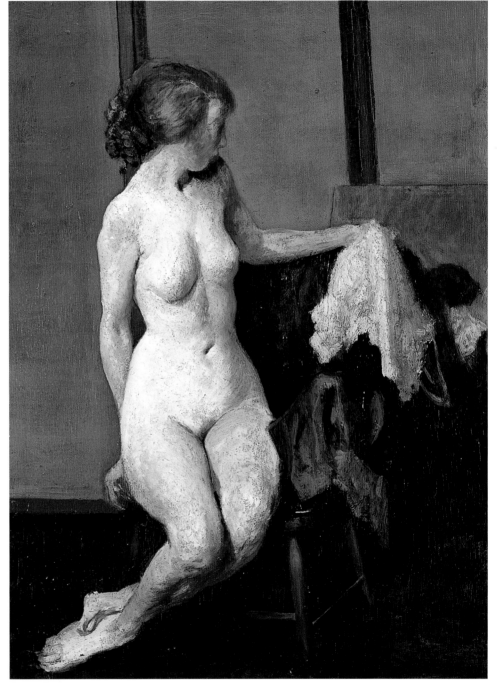

54. *Autumn Leaves*, 1947
Tempera on board
40 x 30 in. (101.6 x 76.2 cm)

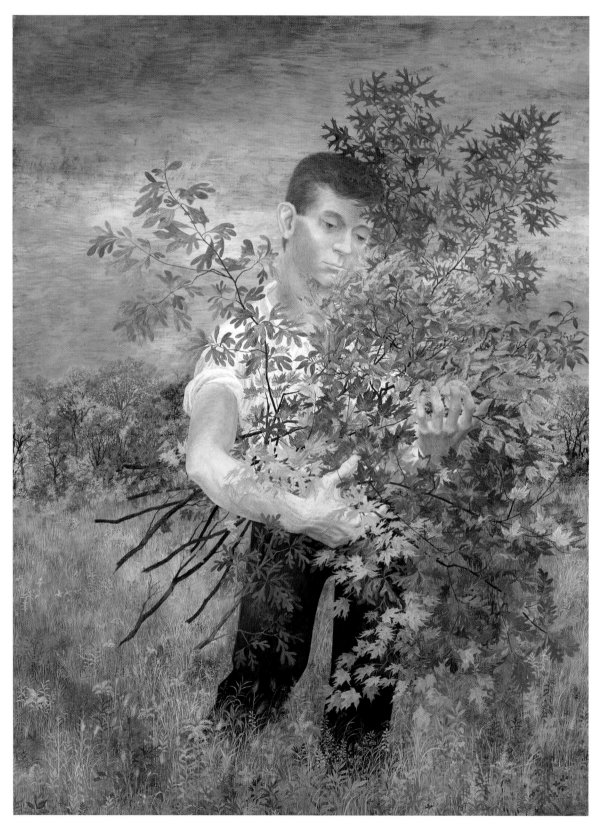

THEODORE ROSZAK

Born POZNAN, POLAND, 1907
Died NEW YORK CITY 1981

55. *Rectilinear Study*, c. 1934–35
Painted wood and metal
7 x 8 5/8 x 3 7/8 in. (17.8 x 21.9 x 9.8 cm)

56. *Man at Machine*, 1937
Oil on canvas
24 x 40 1/8 in. (61 x 101.9 cm)

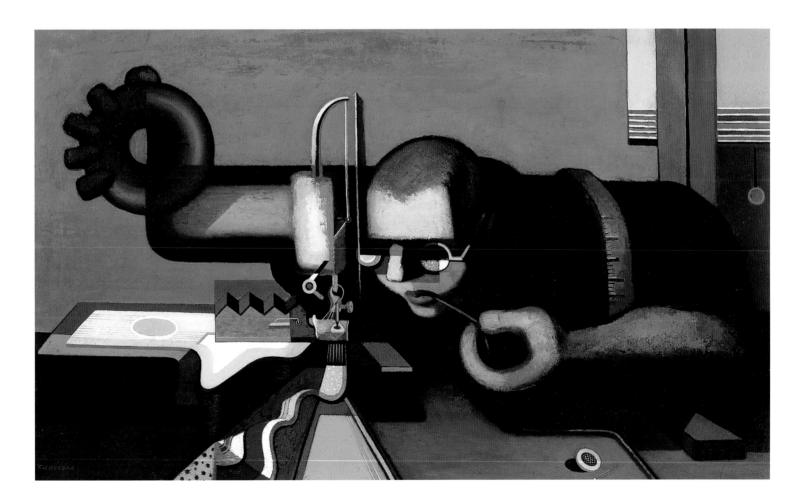

MORGAN RUSSELL

Born NEW YORK CITY 1886
Died ARDMORE, PENNSYLVANIA, 1953

57. *Study for Synchromy in Blue Violet*
(Synchromie en bleu violace [Small]), 1913
Oil on canvas
21 3/4 x 15 in. (55.2 x 38.1 cm)

MORTON L. SCHAMBERG

Born PHILADELPHIA 1881
Died PHILADELPHIA 1918

58. *Self-Portrait*, 1911
Oil on panel
26 x 20 in. (66 x 50.8 cm)

59. *Figure A (Geometrical Patterns)*, 1913
Oil on canvas
32 x 26 in. (81.3 x 66 cm)

BEN SHAHN

Born KOVNO, LITHUANIA, 1898
Died NEW YORK CITY 1969

60. *Self-Portrait among Churchgoers*, 1939
Tempera on Masonite
20 x 29 1/2 in. (50.8 x 74.9 cm)

61. *Death of a Miner*, 1949
Tempera on paper
14 1/2 x 21 3/4 in. (36.8 x 55.2 cm)

CHARLES SHEELER

Born PHILADELPHIA 1883
Died DOBBS FERRY, NEW YORK, 1965

62. *Abstraction, Tree Form*, 1914
Oil on board
13 3/4 x 10 1/2 in. (34.9 x 26.7 cm)

63. *Conversation—Sky and Earth*, 1940
Oil on canvas
28 x 23 in. (71.1 x 58.4 cm)

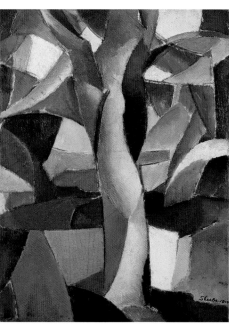

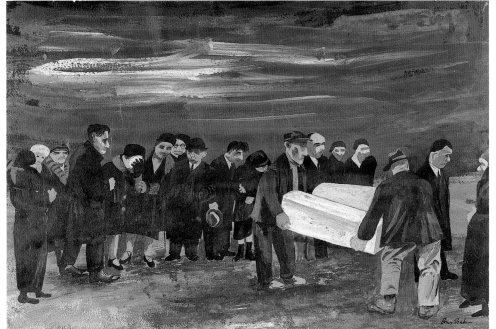

DAVID SMITH

Born DECATUR, INDIANA, 1906
Died ALBANY, NEW YORK, 1965

64. *Winter Window*, 1941
Oil on board
30 x 24 in. (76.2 x 61 cm)

65. *New York No. 1*, 1950
Oil on canvas
13 x 20 in. (33 x 50.8 cm)

66. *Portrait of Jim Robertson, Thanksgiving Day, 1931*, 1931
Oil on canvas
12 x 12 in. (30.5 x 30.5 cm)

RAPHAEL SOYER

Born BORISOGLEBSK, RUSSIA, 1899
Died NEW YORK CITY 1987

67. *Flower Vendor*, 1935 (repainted 1940)
Oil on canvas
30 x 36 in. (76.2 x 91.4 cm)

NILES SPENCER

Born PAWTUCKET, RHODE ISLAND, 1893

Died DINGMAN'S FERRY, PENNSYLVANIA, 1952

68. *The Silver Tanks*, 1949
Oil on canvas
20 x 30 in. (50.8 x 76.2 cm)

JOSEPH STELLA

Born MURO LUCANO, ITALY, 1877

Died NEW YORK CITY 1946

69. *Self-Portrait*, n.d.
Oil on canvas
17 x 15 1/8 in. (43.2 x 38.4 cm)

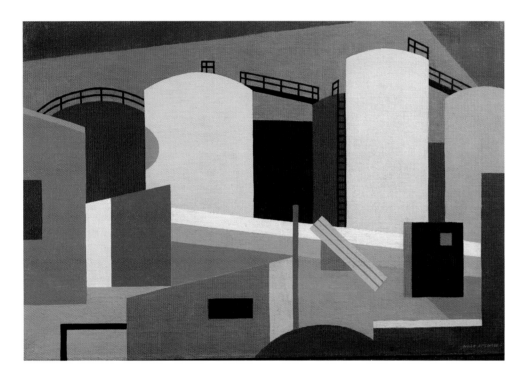

PAVEL TCHELITCHEW

Born KALUGA, RUSSIA, 1898
Died GROTTAFERRATA, ITALY, 1957

GEORGE TOOKER

Born NEW YORK CITY 1920

70. *Weeping Negro*, 1934
Oil and watercolor on pulpboard
29 x 21 in. (73.7 x 53.3 cm)

71. *Self-Portrait*, 1947
Egg tempera on gessoed panel
Diameter: 18 3/4 in. (47.6 cm)

72. *Coney Island*, 1948
Egg tempera on panel
19 1/4 x 26 1/4 in. (48.9 x 67 cm)

73. *The Supermarket*, 1973
Tempera on panel
23 x 17 1/4 in. (58.4 x 43.8 cm)

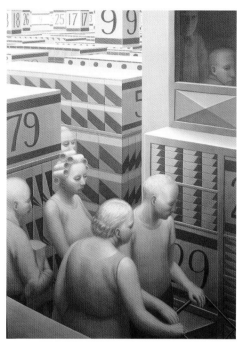

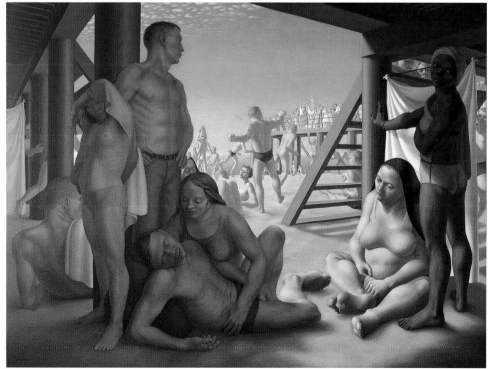

74. *Two Seated Figures*, 1910
Oil on board
47 1/2 x 24 1/2 in. (120.7 x 62.2 cm)

75. *Return from Bohemia*, 1935
Crayon, gouache, and pencil on paper
23 1/2 x 20 in. (59.7 x 50.8 cm)

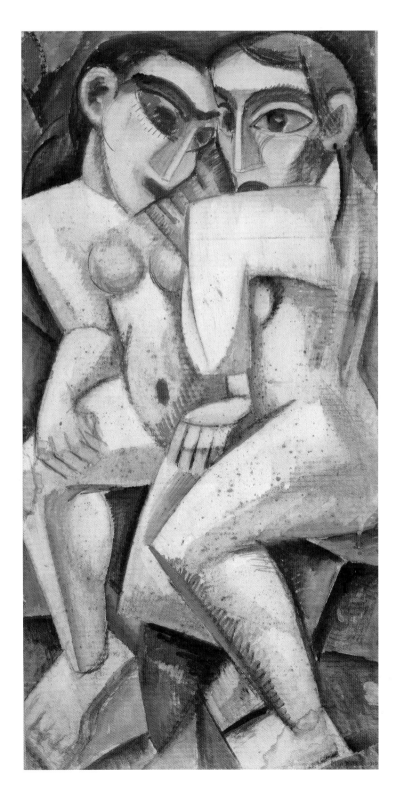

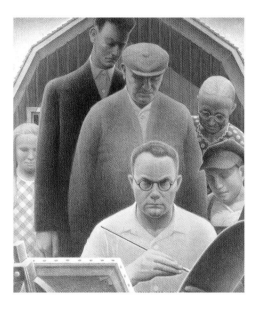

ANDREW WYETH

Born CHADDS FORD, PENNSYLVANIA, 1917

76. *Christina Olson*, 1947
Tempera on panel
32 1/2 x 24 in. (82.6 x 61 cm)

77. *The Huntress*, 1978
Tempera on panel
30 3/4 x 16 in. (78.1 x 40.6 cm)

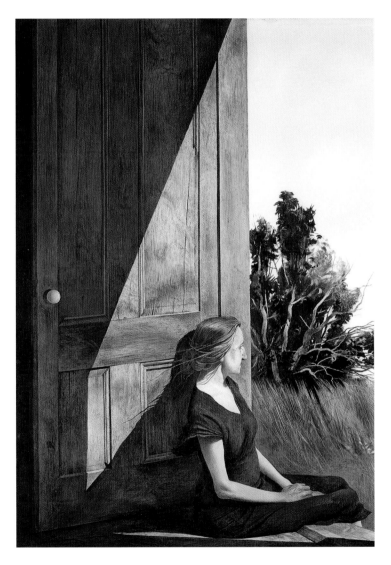

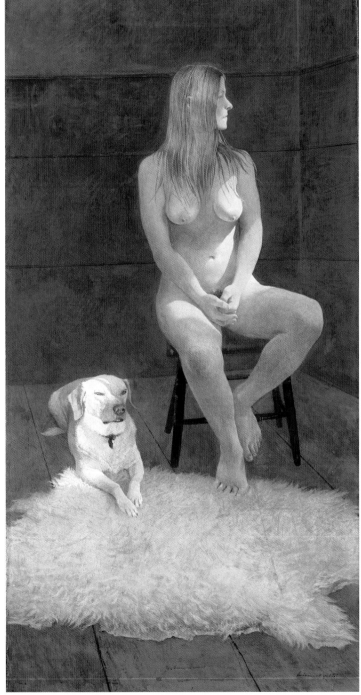

Contributors

William C. Agee is Evelyn Kranes Kossak Professor of Art History at Hunter College, City University of New York.

Elizabeth Armstrong is deputy director for programs and chief curator at the Orange County Museum of Art.

Patricia Sue Canterbury is associate curator in the paintings and modern sculpture department at the Minneapolis Institute of Arts.

Wanda M. Corn is the Robert and Ruth Halperin Professor in Art History at Stanford University.

Bram Dijkstra is professor emeritus of comparative literature at the University of California, San Diego.

Karal Ann Marling is professor of art history and American studies at the University of Minnesota.

Dana Simpson is curatorial research associate at the Orange County Museum of Art.

Orange County Museum of Art Staff

Elizabeth Armstrong
Deputy Director for Programs and Chief Curator

Jennifer Baylis
Education and Public Programs Manager

Kristine Bowen
Director of School and Tour Programs

Brian Boyer
Exhibitions and Facilities Manager

Sherri Bui
Director of Finance

Tom Callas
Registrar

Ryan Callis
Maintenance

Ursula Cyga
Office Manager/Museum Services

John DeMichele
Director of Development

Kelly Dickson
Public Relations Associate

Andrea Dominguez
Family and Community Programs Coordinator

Ashley Eckenweiler
Special Events Manager

Irene Hofmann
Curator of Contemporary Art

Joe Kearby
Finance Coordinator

Robert Laurie
Chief of Security

Janet Lomax
Curatorial Associate

Kristin McCarthy
Development Assistant

Jeanine McWhorter
Director of Visitor Services

Hayley Miller
Museum Stores Director

Karen Moss
*Curator of Collections and Director of
Education and Public Programs*

Dan Rossiter
Chief Preparator

Kiana Sabla
Executive Assistant, Director's Office

Kirsten Schmidt
Director of Marketing and Communications

Dana Simpson
Curatorial Research Associate

Angela Suchey
Museum Stores Buyer

Dennis Szakacs
Director

Tim Tompkins
*Manager of Interpretive Programs and
Education Media*

Mary Trent
Graduate Research Intern

Reproduction Credits

Most photographs appear courtesy of Curtis Galleries, Inc., founder Myron Kunin.
The following list applies to photographs for which a separate acknowledgment is due.
Numbers refer to page numbers used in this catalogue.

© 2005 Estate of Milton Avery/ARS: 117

© 2005 Estate of Romare Bearden; licensed by VAGA: 98, 99, 118

© 2005 Estate of Stuart Davis; licensed by VAGA: 39, 40, 41, 123

© 2005 Estate of Yasuo Kuniyoshi; licensed by VAGA: 132

© 2005 Estate of Reginald Marsh/ARS: 75, 134

© 2005 Estate of Gerald Murphy; licensed by VAGA: front and back covers, 58, 61, 134

© 2005 Estate of Georgia O'Keeffe/ARS: 32, 63, 64, 65, 135

© 2005 Estate of Theodore Roszak; licensed by VAGA: 1, 139

© 2005 Estate of Ben Shahn; licensed by VAGA: 87, 88, 141

© 2005 Estate of David Smith; licensed by VAGA: 142

© 2005 Estate of Raphael Soyer; licensed by VAGA: 11, 143

© 2005 George Tooker and DC Moore Gallery: 8, 108, 110, 111, 145

© 2005 Estate of Grant Wood; licensed by VAGA: 12, 81, 146

© 2005 Andrew Wyeth: 13, 147